paint Realistic Animals in Acrylic with LEE HAMMOND

NORTH LIGHT BOOKS
CINCINNATI, OHIO
www.artistsnetwork.com

Paint Realistic Animals in Acrylic With Lee Hammond. Copyright © 2007 by Lee Hammond. Manufactured in China. All rights reserved. No part of this book may be reproduced in any form or by any electronic or mechanical means including information storage and retrieval systems without permission in writing from the publisher, except by a reviewer who may quote brief passages in a review. Published by North Light Books, an imprint of F+W Publications, Inc., 4700 East Galbraith Road, Cincinnati, Ohio, 45236. (800) 289-0963. First Edition.

Other fine North Light Books are available from your local bookstore, art supply store or direct from the publisher.

11 10 09 08 07 5 4 3 2 1

DISTRIBUTED IN CANADA BY FRASER DIRECT
100 Armstrong Avenue
Georgetown, ON, Canada L7G 5S4
Tel: (905) 877-4411

DISTRIBUTED IN THE U.K. AND EUROPE BY DAVID & CHARLES
Brunel House, Newton Abbot, Devon,. TQ12 4PU, England
Tel: (+44) 1626 323200, Fax: (+44) 1626 323319
Email: postmaster@davidandcharles.co.uk

DISTRIBUTED IN AUSTRALIA BY CAPRICORN LINK
P.O. Box 704, S. Windsor NSW, 2756 Australia
Tel: (02) 4577-3555

Library of Congress Cataloging in Publication Data
Hammond, Lee
 Paint realistic animals in acrylic with Lee Hammond / by Lee Hammond.
 p. cm.
 Includes index. *4342 9793 5/₁₀*
 ISBN-13: 978-1-58180-912-1 (pbk. : alk. paper)
 ISBN-10: 1-58180-912-3 (pbk. : alk. paper)
 1. Animals in art. 2. Acrylic painting--Technique.
I. Title.

ND1380.H34 2007
751.4'26--dc22
 2006036386

Edited by Mary Burzlaff
Designed by Terri Woesner
Production coordinated by Matt Wagner

Lee Hammond and her dog Penny in her studio in Overland ·Park, Kansas.

About the Author

Polly "Lee" Hammond is an illustrator and art instructor. She owns and operates a private art studio called Take It To Art™, where she teaches realistic drawing and painting.

Lee was raised and educated in Lincoln, Nebraska, but established her career in illustration and teaching in Kansas City. Although she has lived all over the country, she will always consider the Kansas City area home.

She currently lives in Overland Park, Kansas, with her family. Lee has been an author with North Light Books since 1994. She also writes and illustrates articles for other publications such as *The Artist's Magazine*. Lee is continuing to develop new art instruction books for North Light and has begun illustrating children's books. Fine art and limited-edition prints of her work will also be offered soon. You may contact Lee via e-mail at Pollylee@aol.com or visit her website at www. leehammond.com.

Metric Conversion Chart		
To convert	to	multiply by
Inches	Centimeters	2.54
Centimeters	Inches	0.4
Feet	Centimeters	30.5
Centimeters	Feet	0.03
Yards	Meters	0.9
Meters	Yards	1.1

Acknowledgments

This is my third book on acrylic painting techniques. Capturing animals in artwork can be a wonderful experience, and painting them in acrylic is fun and exciting. I hope you find this book an inspiring new adventure.

North Light Books has been my family for more than a decade now. I look forward to many more years with them. I could never fully express my gratitude for all they have done for me as an artist.

Thank you, Mary Burzlaff, for helping me once again to create an exciting new book. It would be impossible without your wonderful editorial skill.

A special thank you to Dustin Weant for helping me with the photography in my books.

Dedication

This book is for Mel Theisen, "Tice," who shares my passion for so many things in this world, particularly a love for our little "critters!" Your dedication to caring for animals and to providing homes for ones in need is such a joy to watch. I am looking forward to many years of adding to the ever-expanding "zoo."

Thank you for your loving support and for helping me so much. This book never would have been completed without you quietly and unselfishly taking over the many tasks in my life that were left undone as I dedicated myself to my work. Thank you also for providing me with many of the awesome photos I used for this book.

This book is also dedicated to all of my fans and students. Without you, my career as an artist would not exist. I truly believe that art is wonderful therapy. Each day I receive some form of "thank you" from someone who has discovered the joy of art through my books and the satisfaction that comes from completing the projects offered within their pages. Their happiness is obvious, and I cannot help but believe that this is a living testimonial to the world becoming a better place.

Thank you for your continued support and loyalty. You are more than appreciated; you are inspirational!

Foreword

There are many books about painting, and there are many books on how to draw or paint animals. So what makes this book different from all of the others? If there were only one artistic approach to things, we would need only one book from which to learn. But life (and art) is not that simple. The beauty of this book is that you will learn how to draw *and* paint.

The lessons and examples in this book demonstrate my personal method for painting and capturing accurate shapes in my work. As a creative person, it's up to you to experiment and choose the techniques that fit your own unique, personal style.

More specifically, this book is about my technique for painting animals with acrylic paint. I will never say that it is the "right way" or "only way" to paint. It is merely "my way." For those of you who have never painted with acrylics before, it will be a good introduction to the medium. If you have never drawn animals before, it may be helpful to study one of my other books first, such as *Draw Real Animals!* or *Drawing Realistic Pets From Photographs*. Drawing is an important foundation for painting. Knowing how to render something in graphite first will make your paintings more successful.

However, even if you do not have a lot of drawing experience, the step-by-step approach to the projects in this book will guide you. The grid method will train you to see shapes accurately, allowing you to make your animal paintings look realistic. Take your time, and experiment. Acrylic is a very forgiving medium. If you don't like what you have done, you can simply paint right over it. Relax and enjoy the process, and have a wonderful time with your new adventure. Acrylic is a wonderful medium. The more you use it, the more you will love it!

table of
CONTENTS

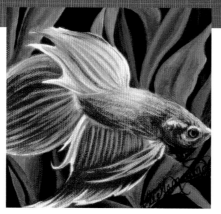

chapter 1
Getting Started 8

You don't need a room full of supplies to start painting with acrylics—just a few paints, brushes and other easy-to-find materials.

chapter 2
Understanding Color 16

Bright, rich acrylic paints are a fun way to explore color. Learn color terms and how to mix an infinite variety of colors from a basic palette.

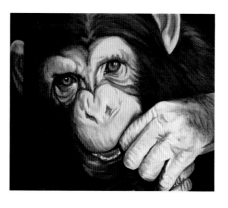

chapter 3
Basic Techniques 25

With these techniques, anyone can draw and paint. Lee shows you basic brushwork, shading and drawing methods.

chapter 4
Painting Animal Features 45

Study the basics for painting animal eyes, mouths, noses, ears and fur. Learn how to observe shape, color and texture in each animal.

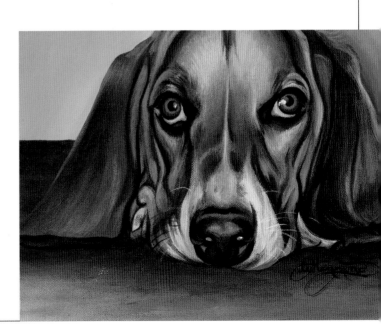

Introduction

I have been writing art technique books for more than a decade. Thus, some publications have dubbed me the "Queen of Drawing!" As flattering as that title is, I want people to know that I do more than just draw.

I love to paint! This is my third book about acrylic painting. The more I write about it, the more I come to love the medium. Acrylic painting is extremely versatile and user-friendly.

As an art instructor, I analyzed my techniques to see how my application differs when painting instead of drawing. I found that I use some of the same thought processes and applications with both, and that I actually "draw with paint," controlling the paint brush much like a pencil.

This book is a collection of colorful projects designed to give you the opportunity to learn how to paint various animals with acrylics. Use the grid method to help with the preliminary sketches. This technique is an easy way to obtain accuracy in your drawings.

When I create my books, I often use the illustrations I am working on as demonstrations in my art classes. My students watch me work and ask questions, which I use to guide me as I write.

Most of the projects have three or four steps to follow. Although many of the projects may look complex, painting with acrylic is all about layers. The paint dries quickly, so it's easy to add details or cover up previous applications. Acrylic is a very forgiving medium.

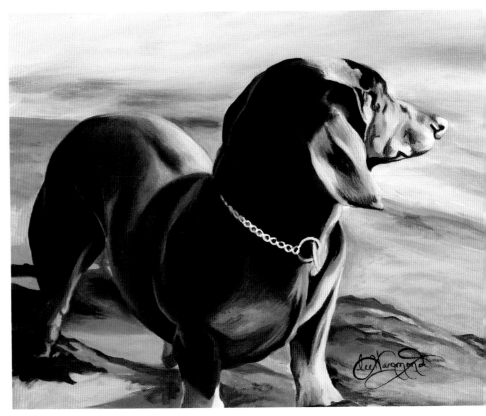

Using Color Layers

This is an example of what you can do if you keep practicing. If you look closely, you will see the layers of colors. Although Petey is a black dog, his coat reflects the colors of his surroundings. You can see the blue and green tones on his back. Reflective color is an important feature in realistic artwork.

Acrylic paintings are "built" much like a three-dimensional object. You start with a basic foundation of color and then add layer after layer. All paintings go through a very ugly "awkward stage," which can be deceiving and frustrating. The following examples will explain this concept in more detail.

Petey at the Lake
11" × 14" (28cm × 36cm)

The Awkward Stage

Acrylic paintings are done in layers. The awkward first layers of the painting are an essential foundation. This stage involves thinned paint with a consistency more like watercolor, applied loosely. Think of the "awkward stage" as a color map. You're simply laying the foundation of the colors that you will build on later.

I have found that many students using acrylics for the first time become frustrated and give up too soon. Because the painting looks so sloppy at first, I understand that you may be convinced that a good outcome is impossible. All paintings go through the awkward stage. If you hang in there for the rest of the process, you'll be amazed at the transformation.

Note From a Student

I am a student of Lee Hammond. I have followed Lee through her books for about fifteen years and have had the pleasure of taking classes from her as well. I always eagerly await the publication of every one of her new books. They have simply changed my life and my art.

Perhaps you are already familiar with her other books and her awesome techniques for graphite and colored pencil. In this book, you will learn more about her painting approach, and you will be hooked too! You are in for a wonderful art experience.

Recently I went to Kansas and took a week-long class in Lee's studio. It was such a thrill to see all of the beautiful work she has created over the years as well as some of the illustrations from her many books up close.

During the visit, I watched Lee work on many of the paintings for this book—what an informative treat that was! It was then that I awakened to one of my problems with art: I want my work to look finished too soon.

I watched Lee's incredible ability and patience as she brought her paintings to the final stage. There is an awkward stage in drawing and painting where most of us stop and are thus dissatisfied. The awkward stage is a very necessary process we need to work through to get to the finished product. Now I realize that, to bring my work to the level I desire, I have to patiently work through this awkward stage.

To all of my fellow students, I guarantee that you can draw and paint too! Lee's books give you all you need to know to accomplish wonderful artwork. All you need to add is the desire, the time and, more importantly, the patience to bring your work to a professional state.

— Nora Martyniak,
Boston

The Awkward Stage Creates Your Color Map
This painting of a cute little dog looks unfinished. The paint is more like watercolor at this stage, and the canvas shows through. This stage acts as a color chart or "road map" for the details to come. This is what I call the "awkward stage."

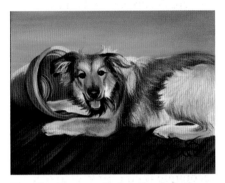

The Final Layers Finish the Painting
This example looks much more professional. By thickening the paint and adding the details one layer on top of another, I have made this painting look more realistic.

Everything pulls together in the final stages. Be patient and don't give up too early. The effort is definitely worth it.

Mischief Maker
9" × 12" (23cm × 30cm)

chapter 1
Getting Started

This chapter covers all the basic supplies you'll need to get started. Since you can't do a thing without paint, we'll start there. When painting with acrylics, I keep things to a minimum. I don't like a million things around me. I use very few colors on my palette and only a few brushes. This makes me feel more relaxed and organized.

Because I use a limited number of supplies, it's easy for me to pack these things into a single tackle box to go teach my workshops or paint on location. It's fun to create a custom art kit. When not in use, your tackle box will act as your storage unit.

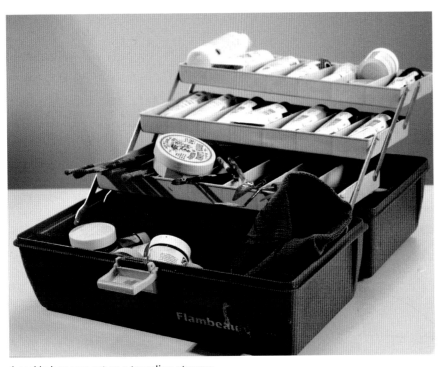

A tackle box can act as a traveling storage unit for your art supplies. It isn't necessary to have a ton of stuff to paint. I keep things to a minimum.

Start-Up Kit

Below is a list of essentials you should have on hand to get started on the painting projects in this book. Happy painting!

Paints
Alizarin Crimson, Burnt Umber, Cadmium Red Medium, Cadmium Yellow Medium, Ivory Black, Prussian Blue, Titanium White

Surfaces
Pre-stretched canvases, canvas panels and/or canvas sheets

Brushes
No. 3 filbert, no. 4 filbert, no. 6 filbert, no. 3/0 round, no. 1 round, no. 2 round, no. 2 flat, no. 4 flat

Palette
Plastic with lid

Other Materials
Cloth rags, wet wipes, cans or jars, spray bottle of water, palette knife, masking or drafting tape, mechanical pencil with 2B lead, ruler, kneaded eraser

What is Acrylic Paint?

Acrylic paints are made of dry pigment in a liquid polymer binder, which is a form of acrylic plastic. Acrylics are water-based, so they do not require paint thinners as oil paints do, though they can be diluted with water while painting.

Acrylic paint dries quickly to a waterproof finish. Because of this quality, it can be used on a variety of surfaces. It's a favorite for painting on windows, outdoor signs, walls and fabric. It is permanent, so items painted with it are washable.

VARIETIES OF ACRYLIC PAINT

Many varieties of acrylic paints are available. Your choice depends partly on the project you're planning to do. There are acrylics formulated for folk art and fine art and even for painting on fabric, walls or signs.

For the projects in this book, look for paints labeled "high viscosity" or "professional grade." Other kinds of acrylic paint will be too thin, with a pigment concentration too low for satisfactory results.

Student-grade paints and those in squeeze bottles generally have a lower concentration of pigment. The pigment is still high quality; there is just a little less of it. Many student-grade paints are so good that professionals use them as well. They are very fluid, easy to work with and easy to mix.

Professional-grade paints have a higher concentration of pigment. They are usually a bit thicker than student-grade paints and their colors may seem deeper and more vivid.

You will find paints in tubes, jars and squeeze bottles. I prefer using paint from a jar rather than from a tube or bottle. Acrylic paint dries quickly, so if I have some uncontaminated color left over on my palette, I return it to the jar to avoid waste. This is not possible with paint from a tube or bottle. I also like jars because I can mix my own custom colors for a painting and store them in separate jars. This is helpful if you are working on a large project and need to keep your colors consistent.

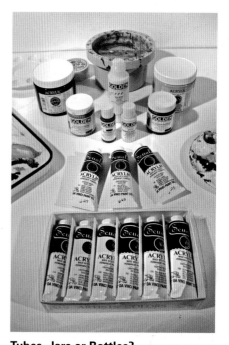

Tubes, Jars or Bottles?
I prefer to use acrylics that come in jars, so I can reuse leftover paint. I can also mix special colors for specific projects, and place those colors in empty jars.

Paint Properties

Each form of paint—jar, tube or squeeze bottle—has different characteristics. Once you've selected the paint you prefer, you will find that individual colors have their own properties as well.

Opacity: Some colors cover surfaces better than others, appearing more opaque, while some will be more transparent. Some colors completely cover the canvas, while others seem streaky. With time and practice, you'll get to know your paints. Play and experiment first by creating some color swatches like the ones on this page. This will give you a better understand-ing of how each color on your palette behaves.

Permanence: Certain colors are more prone to fading over time than others. Most brands have a permanency rating on the package to let you know what to expect. A color with an "excellent" rating is a durable color that will hold its original color for a long time. A color rated as "good" or "moderate" will experience some fading, but not a huge difference over time. A color rated as "fugitive" will fade significantly. You can see this most often with yellows and certain reds. Try to avoid fugitive colors. Regardless of a color's permanence rating, never hang a painting in direct sunlight. Ultraviolet rays in sunlight are the primary cause of fading.

Toxicity: Good-quality paint brands will include some toxic colors. Some of the natural pigments that produce vivid colors are toxic, such as the cadmium pigments and some blues. Never swallow or inhale these colors. Certain colors should never be applied by spraying; check the label. If you're working with children, always find a brand that substitutes synthetic pigments for the toxic ones.

Cadmium Red Medium
This red is opaque and completely covers the canvas. Can you see the difference between this and Alizarin Crimson?

Alizarin Crimson
This red is dark but transparent in nature. It has a streaky appearance, letting some of the canvas show through.

Prussian Blue
This blue is dark but transparent.

Prussian Blue + Titanium White
By adding a touch of Titanium White to Prussian Blue, you can create an opaque version.

Thinning Acrylics With Water

Diluting acrylic paint with water makes it more transparent. This is useful for the beginning stages of a painting, when you are establishing the basic pattern of colors.

Thinned acrylics are often used to create a look very similar to that of watercolor paints. The difference is that acrylic paint is waterproof when it dries. You can add more color without pulling up previous layers. Regular watercolor will rehydrate when wet paint is applied on top of it, usually muddying the colors.

Begin With an Underpainting of Thinned Acrylics

In the example above you can see how I begin my paintings. It looks very underdeveloped, but it gives me a good foundation to work on. The colors of the entire painting, including the background, are established first. The details come later. While this painting of a betta fish is pretty, it looks unfinished.

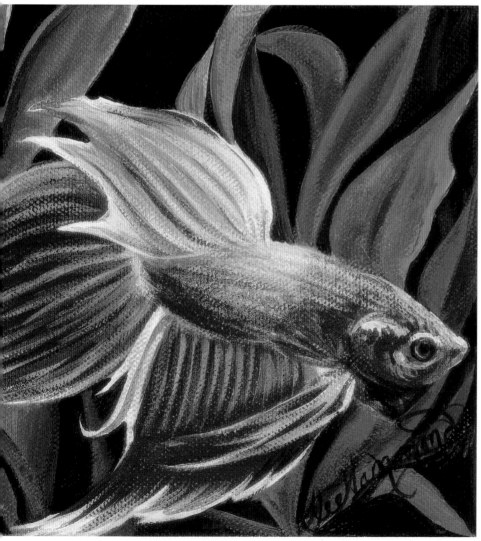

Finish With Purer Pigment

Use undiluted paint or reduce the amount of water you mix with the paint for the finishing details of your painting. The pigment will be much more opaque. The thicker paint will cover up the first layer. You can see the changes in the paint's appearance. The painting now looks more realistic.

Betta
5½" × 5½"
(14cm × 14cm)

Choosing Brushes

While there are endless varieties of brushes to choose from, I have included only the ones I use most frequently. Read all about brush basics here, and see the list on page 8 for the basic set of brushes that you'll need for the projects in this book.

BRISTLE TYPE

The way paint looks when applied to canvas largely depends on the type of brush you use. Brushes come in a variety of bristle types.

Stiff bristle: These brushes are made from boar bristle, ox hair, horsehair or other coarse animal hairs.

Sable: These brushes are made from the tail hair of the male kolinsky sable, which is found in Russia. This very soft hair creates smooth blends. The scarcity of the kolinsky makes these brushes expensive, but they are worth it!

Squirrel hair: These soft brushes are a bit fuller than sable brushes. They are often used for watercolor because they hold a lot of moisture.

Camel hair: This is another soft hair that is used frequently for both acrylic and watercolor brushes.

Synthetic: Most synthetic bristles are nylon. They can be a more affordable substitute for natural-hair brushes, but paint is very hard on them. They tend to lose their shape and point faster than natural-hair brushes.

Good brush cleaning and care (see page 13) are essential to making brushes last. Natural-hair brushes can be quite pricey. However, if cleaned properly, they will last longer than synthetic ones.

BRUSH SHAPE

Brushes come in different shapes, and some shapes are better for certain paint applications. Below is a list of the different brush shapes and the best uses for each.

Flat: A flat brush is used for broad applications of paint. Its wide shape will cover a large area. The coarse boar-bristle type is a stiff brush that can be used to literally "scrub" the paint into the canvas. A softer sable or synthetic bristle is good for smooth blending with less noticeable brush marks.

Bright: Brights are very similar to flats; however, the bristles are a bit longer, which gives the brush more spring.

Round: Use round brushes for details and smaller areas. The tip of a stiff bristle round is good for dabbing in paint or filling in small areas. A small soft round can be used in place of a liner brush for creating long straight or curved lines.

Filbert: This brush shape is my personal favorite. Also known as a "cat's tongue," the filbert is useful for filling in areas, due to its rounded tip.

Liner: The liner's small, pointy shape makes it essential

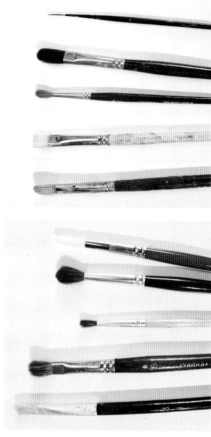

Top Set: From top to bottom: liner, filbert, round, bright and flat brush shapes.

Bottom Set: From top to bottom: synthetic, camel hair, squirrel hair, sable and stiff bristle types.

for detail work. You can create tiny lines and crisp edges with a liner.

Hake: A hake (pronounced hah-kay), a wide, flat oriental brush made from natural hair, is excellent for soft blending.

Brush Maintenance

Acrylic paint is hard on brushes. Remember, once acrylic paint dries, it is waterproof and almost impossible to remove. Paint often gets into the brush's *ferrule* (the metal band that holds the bristles in place). If paint dries there, it can make the bristles break off or force them in unnatural directions. A brush left to dry with acrylic paint in it is as good as thrown away.

Follow these pointers to keep your brushes like new for as long as possible:

- Stick to a strict and thorough brush-cleaning routine. See the sidebar for my favorite cleaning procedure. (Note: Some paint colors stain synthetic bristles. This staining is permanent, but normal and harmless.)
- Never leave a brush resting in a jar of water. This can bend the bristles permanently. It can also loosen the ferrule, causing the bristles to fall out. (Sometimes a brush with five hairs is good for small details, but not if the poor brush started out with a hundred!)
- Always store your brushes handle-down in a jar, can or brush holder to protect the bristles.

How to Clean Your Brushes

1. Swish the brush in a jar of clean water to loosen any remaining paint.
2. Take the brush to the sink and run lukewarm water over it.
3. Work the brush into a cake of "The Masters" Brush Cleaner and Preserver until it forms a thick lather. At this point, you will notice some paint color leaving the brush.
4. Gently massage the bristles between your thumb and fingers to continue loosening the paint.
5. Rinse under the warm water.
6. Repeat steps 3 to 5 until no more color comes out.
7. When you are sure the brush is clean, apply some of the brush cleaner paste to the bristles and press them into their original shape. Allow the paste to dry on the brush. This keeps the bristles going the way they are intended and prevents them from drying out and fraying. It's like hair conditioner for your brushes. When you are ready to use the brush again, simply rinse the soap off with water.

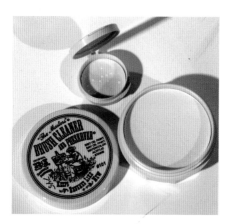

My Favorite Brush Cleaner

I've used "The Masters" Brush Cleaner and Preserver for many years and swear by it. It's helped me remove some pretty stubborn paint from old brushes. Before throwing a brush away, I always try to rescue it with the soap first. A good paint-brush will have a very long life if taken care of properly.

Long or Short Brushes?

You will see brushes with both short handles and long. Long handles are designed for standing at an easel, so you can paint at arm's length and step back and see what you are doing. Short handles are more for painting while sitting, and working on small details.

Proper Brush Storage

Always store your bristles in the "up" position!

Painting Surfaces

Many students ask me what the best painting surface is. This depends on your preference and what kind of painting you are doing. Acrylic paint can be used on everything from fine art canvases to wood, fabric, metal and glass. For our purposes in this book, I will concentrate on surfaces normally used for paintings.

PRE-STRETCHED CANVAS

Pre-stretched canvas provides a professional look, making your work resemble an oil painting. It is easily framed and comes in standard frame sizes from mini (2" × 3" [5cm × 8cm]) to extra large (48" × 60" [122cm × 152cm] or larger). You will notice a bit of "bounce" when applying paint to pre-stretched canvas.

Pre-stretched canvas comes "primed," which means it's coated with a white acrylic called *gesso* to protect the canvas from the damaging effects of paint.

Pre-stretched canvas can be regular cotton duck, which is excellent for most work; extra-smooth cotton, often used for portrait work; or linen, which also is smooth.

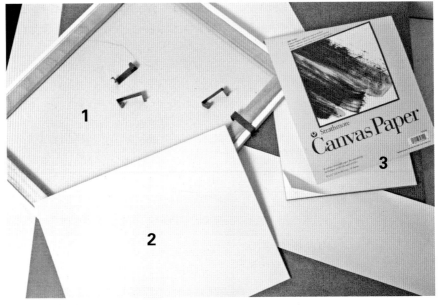

Painting Surfaces
Pre-stretched canvas (1) is the most popular surface for fine art painting. It must go into a frame "as is" and is held in place with frame clips. These are metal brackets that snap over the wooden stretcher frames and grip the inside edge of the frame with sharp teeth.
Canvas panels (2) consist of canvas on cardboard backings. They are more rigid than stretched canvas, and the finished piece can be matted and framed.
Canvas sheets (3) also can be matted and framed. They are found in single sheets, packages and pads.

CANVAS PANELS

Canvas panels are canvas pieces glued onto cardboard backings. They are a good alternative to pre-stretched canvas if you would prefer something less expensive. A canvas panel is very rigid and will not give you the bouncy feel of painting on stretched canvas.

With canvas panels, unlike pre-stretched canvas, you have the option of framing with a mat. A colored mat can enhance the appearance of framed artwork. A canvas panel also allows you to protect your painting with glass.

CANVAS SHEETS

Another alternative is canvas sheets. Some brands are pieces of actual primed canvas, not affixed to anything. Others are processed papers with a canvas texture and a coating that resembles gesso. Both kinds can be purchased individually, in packages or in pads.

With canvas sheets, as with canvas panels, framing can be creative. Sheets are lightweight and easy to mat and frame. For the art in this book, I used mostly canvas sheets.

Palettes and Other Tools

The last few items to gather to make your painting experience more organized and pleasurable are not expensive, and usually can be found around the house.

PALETTES

I prefer a plastic palette with a lid, multiple mixing wells, and a center area for mixing larger amounts of paint. Because acrylic paint is a form of plastic, dried acrylic can be peeled or soaked from a plastic palette. I find this more economical than disposable paper palettes.

Many artists make their own palettes using old dinner plates, butcher's trays or foam egg cartons. Use your creativity to make do with whatever you have on hand.

OTHER TOOLS OF THE TRADE

Cloth rags: Keep plenty of these handy. Keep one near your palette to wipe excess paint from your brush. You also need one to wipe excess water from your brush. Paper towels work too, but they can leave lint and debris.

Containers: Collect jars, cans and plastic containers to use as storage for brushes or as water containers as you work.

Spray bottle: Use a spray bottle to mist your paints to prevent them from drying out as you work. Acrylic paints will "skin over" in no time at all.

Palette knife: Use a palette knife to transfer acrylic paint from a jar to the palette (and vice versa), and to mix the paint on the palette.

Lighter: Sometimes acrylic paint dries inside the cap of a tube of paint (another reason I prefer jars). To loosen the paint, run the cap under very hot water. If it is really stuck, holding it over the flame of a lighter for a few seconds will loosen it enough to allow you to twist off the cap.

Drafting tape: If you use canvas sheets, tape them to a backing board as you work. To tape the edges of your paper down, use drafting tape or painter's tape. This type of tape won't damage or rip the paper.

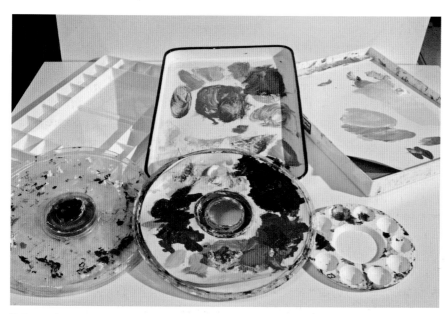

Palette Choices
Palettes come in many varieties. It is easy to make your own with plates, egg cartons or plastic containers. Be creative!

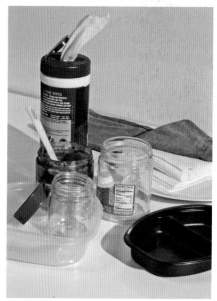

Additional Materials
Look around your house for handy items such as jars, plates, plastic trays, wet wipes and rags.

chapter 2
Understanding Color

Acrylic's bright, rich pigments are fun to experiment with. Artists tell a lot about themselves by the colors they choose. But understanding what color to use is much more than just experimenting or choosing colors because you like them. Color theory is scientific.

Colors react to each other, and placing certain colors together can make quite a statement. To fully understand how colors work, it's essential to know the color wheel. You'll learn about the color wheel and some important color terms in this chapter.

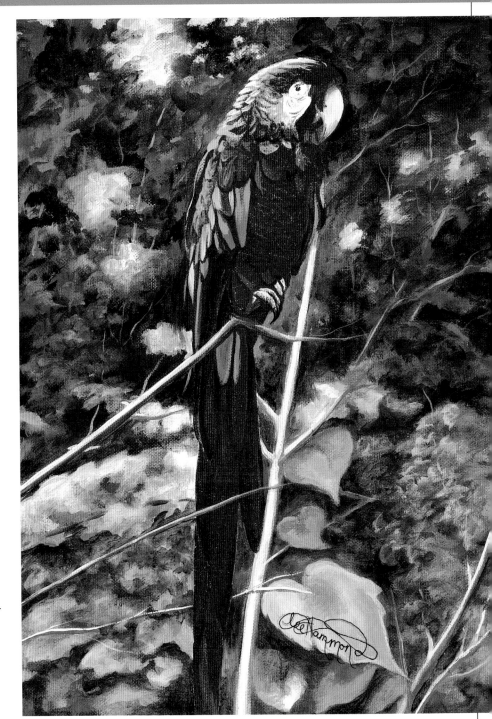

Bright, Bold Acrylic Colors
Acrylic paint is wonderful for creating bright, bold colors. This painting of a macaw parrot is an example of a red/green complementary color scheme. It also shows how vibrant acrylic color can be.

Macaw in the Wild
16" × 12" (41cm × 30cm)

Color Basics

Acrylic painting is a wonderful way to explore color theory. Its bright pigments are fun to experiment with. Here are the basic color relationships to know.

Primary colors: The primary colors are red, yellow and blue. They are also called the "true" colors. All other colors are created from these three. Look at the color wheel and see how they form a triangle if you connect them with lines.

Secondary colors: Each secondary color is created by mixing two primaries together. Blue and yellow make green; red and blue make violet; and red and yellow make orange.

Tertiary colors: Tertiary colors are created by mixing a primary color with the color next to it on the color wheel. For instance, mixing red and violet produces red-violet. Mixing blue with green makes blue-green, and mixing yellow with orange gives you yellow-orange.

Complementary colors: Any two colors opposite each other on the color wheel are called complementary. Red and green, for example, are complements. The painting on the facing page is an example of a complementary color scheme. The red and green contrast beautifully, each color making the other one really stand out.

OTHER COLOR TERMS TO KNOW

Hue: Hue simply means the name of a color. Red, blue and yellow are all hues.

Intensity: Intensity means how bright or dull a color is. Cadmium Yellow, for instance, is bright and high intensity. Mixing Cadmium Yellow with its complement, violet, creates a low-intensity version of yellow.

Temperature: Colors are either warm or cool. Warm colors include red, yellow, orange and any combination of these. When used in a painting, warm colors appear to come forward. Cool colors include blue, green, violet and all of their combinations. In a painting, cool colors will seem to recede.

Often, there are warm and cool versions of the same hue. For instance, I use Cadmium Red and Alizarin Crimson. While both are in the red family, Cadmium Red is warm, with an orangey look, and Alizarin Crimson is cooler, because it leans toward the violet family.

Value: Value means the lightness or darkness of a color. Lightening a color either with white or by diluting it with water produces a tint. Deepening a color by mixing it with a darker color produces a shade. Using tints and shades together creates value contrast.

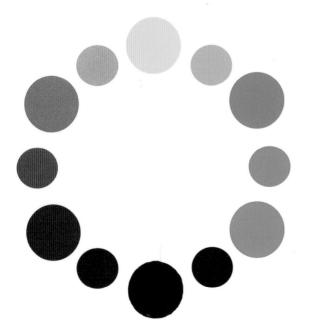

The Color Wheel

The color wheel is a valuable tool for learning color theory. Red, yellow and blue are the primary colors; orange, green and violet are the secondaries. The rest are called tertiaries. For practice, make a color wheel of your own.

Your Basic Palette and How to Expand It

Most artists want to have all of the toys associated with their craft. I love nothing more than a set of art supplies with a hundred different colors to choose from. But, while it sounds like artistic nirvana, it's really not necessary. Mixing the colors you need from just a few pigments is much more rewarding, educational and economical.

YOUR BASIC PALETTE

With a very small palette of only seven colors, you can create an endless array of color mixes.

Two Neutral Colors

Ivory Black Titanium White

Three Primary Colors

Cadmium Yellow Cadmium Red Prussian Blue
Medium Medium

Two Additional Colors

Alizarin Crimson Burnt Umber

Tints
Mixing a palette color with white produces a tint.

Cadmium Yellow Cadmium Red Alizarin Crimson
Medium + Tita- Medium + + Titanium White
nium White = pale Titanium White = = pink
yellow peach/coral

Burnt Umber + Prussian Blue + Ivory Black +
Titanium White = Titanium White = Titanium White =
beige sky blue gray

Shades
Mixing a palette color with black produces a shade.

Cadmium Yellow Cadmium Red Alizarin Crimson
Medium + Ivory Medium + Ivory + Ivory Black =
Black = dark olive Black = maroon plum
green

Burnt Umber + Prussian Blue +
Ivory Black = dark Ivory Black = dark
brown blue

Greens

Greens can be difficult to mix due to the hundreds of possible variations. You can achieve green with yellow and blue, or with yellow and black. Adding brown yields an "earthy" green.

Cadmium Yellow Medium + Ivory Black = olive green

olive green mix + Titanium White = grayish green

Prussian Blue + Cadmium Yellow Medium = green

green mix + Titanium White = mint green

Violets and Purples

Various violets and purples can be created by mixing Cadmium Red Medium and Prussian Blue or Alizarin Crimson and Prussian Blue. Adding white to these mixes will give you lavender, orchid, mauve and so on.

Cadmium Red Medium + Prussian Blue = maroon

maroon mix + Titanium White = warm gray

Alizarin Crimson + Prussian Blue = plum

plum mix + Titanium White = lavender

Oranges

Cadmium Red Medium or Alizarin Crimson mixed with Cadmium Yellow Medium will produce various oranges. Adding Titanium White to these colors will give you coral, peach, melon and so on.

Cadmium Red Medium + Cadmium Yellow Medium = orange

orange mix + Titanium White = peach

Alizarin Crimson + Cadmium Yellow Medium = orange-red

orange-red mix + Titanium White = coral

Earth Tones

Earth tones can be created by adding different colors to Burnt Umber. All of these colors can be turned into a pastel by adding Titanium White. These swatches show the earth tone mix (top swatch), and what it looks like with white added (bottom swatch).

Burnt Umber + Cadmium Yellow Medium = raw umber

Burnt Umber + Cadmium Red Medium = brick red

Burnt Umber + Prussian Blue = deep navy blue

Burnt Umber + Ivory Black = dark sepia

Burnt Umber + Cadmium Yellow Medium + Titanium White = beige

Burnt Umber + Cadmium Red Medium + Titanium White = mauve

Burnt Umber + Prussian Blue + Titanium White = steel blue

Burnt Umber + Ivory Black + Titanium White = warm gray

Mixtures for Hair and Fur Tones

It would be much easier to paint animals if they all looked alike, but obviously that is not the case. The wide variety of colors and hair types of the myriad animals in the world can be mind-boggling. Some have very short hairs that are barely discernible. Some have very long hair, and some have a combination of the two (consider a horse, with its short hair and long mane and tail).

When painting an animal from a reference photo, study your picture carefully to discern how the light and shadows and layers of fur change the color. It's important to avoid using the same "formula" over and over, or all of your work will start to look the same and lose its realistic quality.

The following paint swatches will give you some of the most common hair tones and the formulas for creating them. It is impossible to create a swatch for every color seen in nature. These swatches merely represent a few of the hues often seen in the animal kingdom.

Hair Color, Brown Tones

This light color forms the beginning of all the brown tones. Create it with Titanium White and Burnt Umber. The value scale shows the range of tones that can be created with this simple color mixture.

Hair Color, Red Tones

Add a touch of Cadmium Red Medium to the brown mixture to create this reddish hue. Look at the wide variety of tones in the value scale. Add more Titanium White to make it paler or more Burnt Umber to make it deeper. The Cadmium Red Medium makes it much warmer.

Hair Color, Black Tones

Black is never pure black. These two swatches show cool and warm variations of black. The first one shows Ivory Black mixed with Prussian Blue and green (made from Prussian Blue and Cadmium Yellow Medium). This deep teal hue is a cool color, and it is often seen reflecting off black animals' fur. The second shows a warm black created by adding Alizarin Crimson and Cadmium Red Medium. See page 24 for an example of how these colors are used.

Hair Color, Yellow Tones

This color is similar to the original brown mixture, but it has a hint of Cadmium Yellow Medium. Black and yellow make olive green, so the touch of Cadmium Yellow Medium gives the color a bronze hue. This value scale gives you a wide range of tones. The greenish color is easy to see.

Hair Color, White Tones

White fur is never pure white. It is a combination of white and hints of other colors. These swatches show both cool and warm variations. The first is made with a hint of Ivory Black to create gray tones. The second is made with a hint of Burnt Umber for a tan tint. See page 23 for an example of how these colors are used.

Color Schemes

The right color scheme is one that represents the subject yet also adds interest for the viewer. Experiment with color to achieve the exact feel you want your painting to have.

COMPLEMENTARY COLORS

Complementary colors are colors opposite each other on the color wheel (see page 17). When complements are used near each other, they contrast with and intensify each other.

When complementary colors are mixed, they gray each other down. You can use this information to darken a color without killing it. When darkening a color to paint shadows, you may instinctively reach for black. But black is a neutral color and will produce odd results in mixtures. Instead, darken a light color with its complement.

When complements are used together in a painting, each helps the other stand out, as seen in the three examples on this page. By mixing the complementary colors to create tones, the colors are deepened but not ruined. The warm color will come forward, and the cool color will recede.

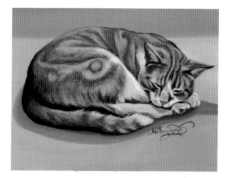

Complements: Orange and Blue

This painting of my cat Burnie is an example of using complements. The orange colors in his fur are enhanced by the blue tones in the background. Remember the color wheel when creating your paintings, and allow the colors to work together for the best impact. Not only is it a scientific way of enhancing your work, it's fun!

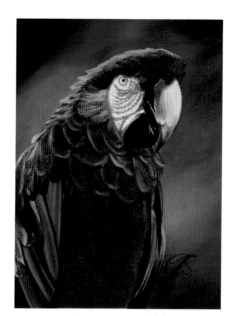

Complements: Red and Green

A red color scheme can be made more vibrant by using green in the background. Adding green to the red paint gave me a good color to use in the shadow areas. This closeup of a parrot's face is similar to the painting on page 16.

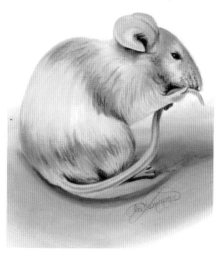

Complements: Yellow and Violet

The warm yellow tones in the rat are intensified by the violet colors in the background and shadow areas. I reflected the violet colors in the rat's fur, creating shadows and giving it a more realistic appearance. The warm yellow tones seem to come forward, while the yellow mixed with the cool violet makes the shadow areas recede.

MONOCHROMATIC

A painting created by using variations of only one color is called monochromatic. Working monochromatically is a good way for a new student to begin painting. It simplifies the procedure, allowing the student to concentrate on the process rather than on color theory.

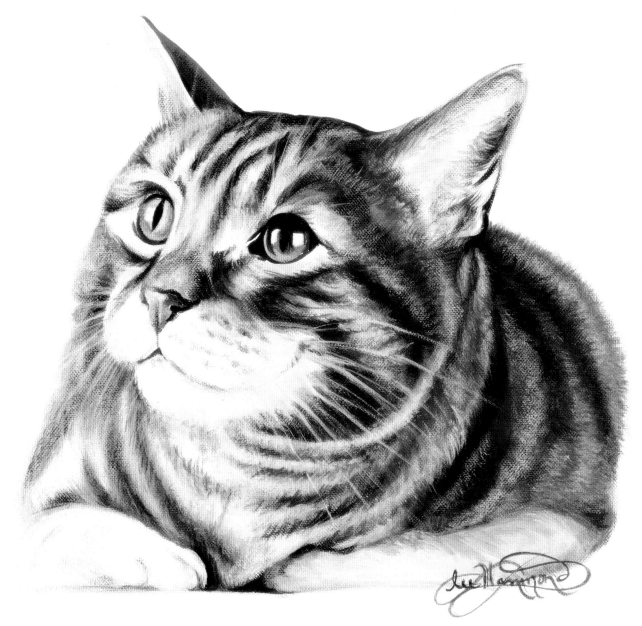

The Drama of Black and White

A monochromatic painting can look very dramatic, like this painting of a cat.

Kitty
9" × 12" (23cm × 30cm)

Reflected Colors

I often tell my students, "black isn't black and white isn't white." Both black and white are considered neutral colors, and in nature they are both very reflective. While all colors reflect their surroundings, the neutral nature of black and white makes reflected color stand out even more.

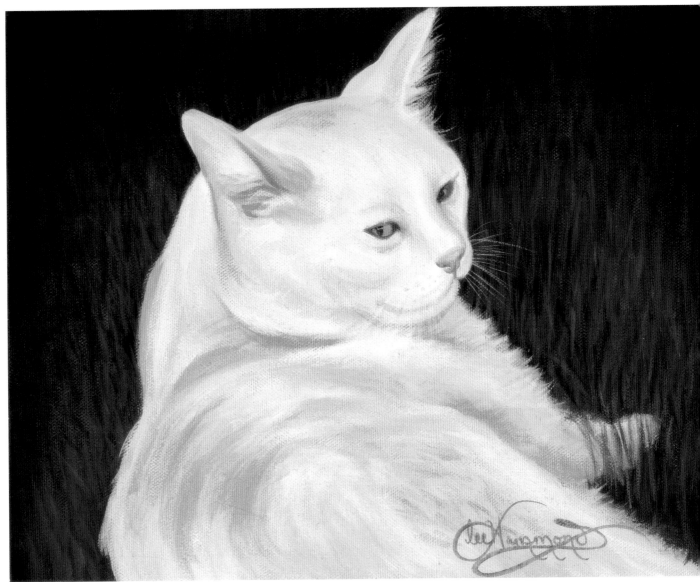

Portrait of Nubby
9" × 12" (23cm × 30cm)

White Isn't White

Look at this painting of my cat Nubby. He is extremely white in color, but, when he is lying out in the yard, the colors of his surroundings bounce off his white coat. You can see the blue of the sky, the green of the grass and some violet. All of these reflected colors help make the painting more realistic. Imagine what it would have looked like had I just used black for the shadow areas. It would have looked dull and inconsistent with the green grass surrounding the cat.

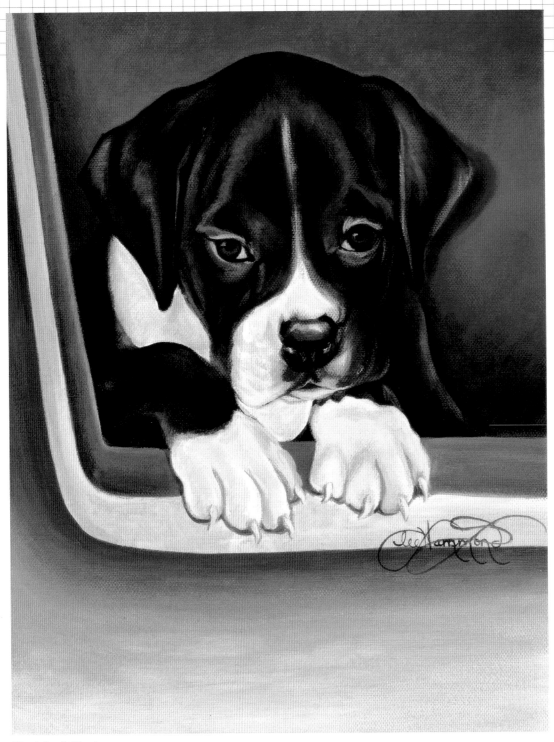

Black Isn't Black

This painting of a black puppy is far from being pure black. You can clearly see the blue and aqua colors of the background reflecting off his sleek coat, giving it a beautiful colorful glow. The brown tones of the ledge he is resting on bounce up onto his side and front leg. Always study your reference photo for this type of color transfer on your subject.

A Black Puppy
12" × 9" (30cm × 23cm)

chapter 3
Basic Techniques

Learning something new is always a bit intimidating. As with anything else, the best teacher is experience—trial and error. This chapter will show you how to grab a brush, dip it in the paint and experiment. In no time you should feel comfortable enough to do the projects to come. Remember, acrylics are highly forgiving. If you don't like something, you can simply cover it up.

The exercises in this section will give you a feel for how to use flat, filbert, round and liner brushes. You will also learn the five elements of shading and how to use them to create the illusion of three dimensions on a flat canvas. Finally, you will see how the grid method of drawing will enable you to draw any subject.

Practice Makes Perfect

Practice holding each type of paint brush and learn the type of stroke it is designed for. Practice is essential and will give you the confidence you need to move on to a finished piece of art.

Blending With a Flat Brush

Flat brushes are most commonly used for applying large areas of color and for creating blended backgrounds. The colors seen here are Prussian Blue and Titanium White. Try it again with different colors.

MATERIALS

paints
Prussian Blue, Titanium White

brushes
any flat brush

1 Place a blob of Titanium White about the size of a large grape on your palette.

2 Add just a touch of Prussian Blue to the white.

3 Mix another blob of paint that is twice as dark as the first.

4 Dip your brush into the darker of the two blues you mixed in steps 2 and 3. Hold the brush flat against the canvas and evenly distribute the paint with long, sweeping strokes. Quickly go back and forth until the paint covers the canvas. Don't leave any of the canvas showing through the paint.

If your paint feels stiff and hard to move, dip just the tip of the brush in the water and mix the paint until it is creamier. Don't add too much, or the paint will be too thin and appear transparent. I like to make my paint the consistency of thick hand lotion.

5 When you have a wide stretch of dark blue, dip into the lighter blue and apply it to the canvas slightly below the first stripe, using the same stroke. Stroke back and forth to blend the two blues as evenly as possible. Use a clean, dry flat to further blend and soften. Blending takes practice.

To create a mottled look, like a photographer's background, you can apply areas of light and dark and blend them together. Scrub the paint in a circular fashion to get the swirled look often seen in photographs.

A Dab and a Touch Will Do

When mixing paint, I often refer to two terms: a *dab* and a *touch*.

A *dab* is a good-sized dip into the darker paint, which will usually cover the tip of the brush.

A *touch* is a gentle dip of the corner of the bristles, picking up a slight amount.

Always start mixes with the lighter pigment.

Using a Filbert Brush

A filbert brush is very similar to a flat, but the tip is rounded much like the shape of a tongue. (That's why it's sometimes called a "cat's tongue.") I like to use these brushes for almost everything that requires filling in. The rounded edges fit comfortably when going along curved edges.

There are several different ways to apply paint with a filbert. The first is the transparent approach, using very diluted paint. The second is a smooth, blended approach, which gives the canvas complete, even coverage. The third is created with a scrubbing motion and fairly dry paint. This dry-brush approach creates the appearance of texture.

A filbert can be used to apply a transparent layer of diluted paint.

This is an example of a smooth application that completely covers the canvas.

The dry-brush application creates texture.

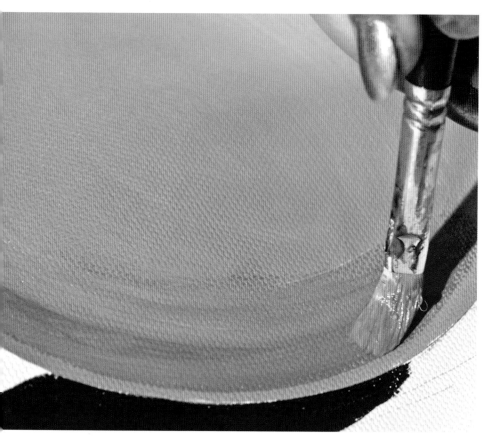

A filbert brush makes filling in an animal shape much easier.

Using Round and Liner Brushes

Pointed brushes such as round and liner brushes are excellent for creating lines and small details. They come in a variety of sizes and are essential for painting hair and fur. They are also good for making small dots for highlights and textures. I use soft synthetics or sable brushes for these techniques.

Use the tips of round and liner brushes. Don't place a lot of pressure on them or you'll cause the bristles to bend. Here are some hints to guide you in using liner and round brushes.

Note

Use soft sable or synthetic brushes for these exercises.

A small round brush, such as a no. 3/0, will create the look of hair strands. It is important to use thin paint and quick strokes or you will end up with lines like these. They are too harsh and even and do not look like fur.

Dilute your paint until it has the consistency of thick ink. It needs to be fluid but not transparent. Paint in the hair strands with quick strokes, lifting the brush up slightly as you go. This will make the line taper at the end, creating more natural-looking hair strands.

Never apply fur strokes directly to the white of the canvas. You must first apply a layer of color. The examples on this page are monochromatic in black and white. I applied a medium gray tone to the canvas first and then applied the brushstrokes to create fur.

The length of your brushstroke will represent the length of the hair. Many quick, overlapping strokes will create the illusion of layers. Remember to keep your paint fluid by adding a few drops of water as you work.

Drybrushing and Scrubbing

So far you've been using paint that has been thinned to make it more fluid. This time you will be using very dry paint with a technique called drybrushing. It creates a rough, textured appearance because the paint is so dry and is used so sparingly that it doesn't fully cover the canvas.

You can also drybrush to add a thin layer of color to an already painted area to subtly change the look. I use this technique a lot in animal paintings to add a hint of color or the glisten of a highlight to the outer surface of the fur.

For this technique, use a sable or synthetic filbert or flat brush. Their shapes work well for both scrubbing and drybrushing. Once the shape and foundation of the animal are painted, I use a scrubbing motion to drybrush in the small details of color and tone.

Drybrush to Add Glisten and Highlight

Lightly dip the edges of the bristles of whatever brush you're using into full-strength paint. Wipe it back and forth on the palette to remove any excess, then lightly scrub the color onto the painting surface with short strokes. Because there is barely any paint on the brush, the paint will fade into what is already there.

A Closer Look

Analyze this painting for the techniques and brushstrokes we have covered so far. Each area of the painting was created with a unique approach to achieve its varied textures and surfaces. Some surfaces are smooth, while some are richly textured.

This painting is a good example of what you can expect when painting animals. It's important to analyze your reference photo for the textures you will be required to produce. For this painting, I had to create smooth areas as well as more textured areas to replicate short and long hair. Contrasts in textures make more interesting paintings.

The lighting of this piece creates a sense of mystique. I seem to migrate toward extreme contrasts. The black background gives this piece dramatic intensity, making the face of the chimpanzee seem to rise out of the darkness. The value contrast causes the warm brown tones of the face and fur to glow.

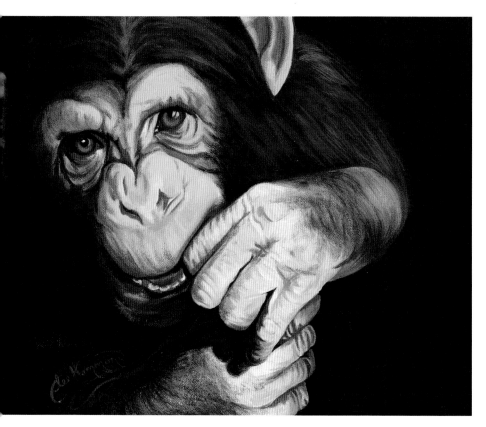

Identifying Brushes and Strokes

This painting has a lot of interesting qualities due to its range of contrasting textures. Identify the type of brush and stroke used in each area.

1. **Facial contours and fingers:** Flat brush, drybrushing.
2. **Tops of the hands:** Flat brush, scrubbing.
3. **Hair:** Small round or liner brush, quick strokes.
4. **Face and Fur:** Filbert brush, smooth fill-in technique.

Up Close and Personal
12" × 16"
(30cm × 41cm)

30

The Five Elements of Shading

I start every new student with this valuable lesson: the foundation for any realistic rendering, regardless of the medium, can be found in the five elements of shading a sphere. If you can create a believable and realistic depiction of a sphere (a ball on a table), the ability to render everything else is right at your fingertips.

So why is understanding the sphere so important when painting animals? Much of an animal's shape is curved and rounded, as is the surface of a sphere.

1 **Cast shadow:** This is the darkest tone on your drawing. It is always opposite the light source. In the case of the sphere, it is underneath, where the sphere meets the table. This area is devoid of light because, as the sphere protrudes, it blocks light and casts a shadow.

2 **Shadow edge:** This dark portion is not at the very edge of the object. It is opposite the light source where the sphere curves away from you.

3 **Halftone:** This is a medium value. It's the area of the sphere that's in neither direct light nor shadow.

4 **Reflected light:** This is a light tone. Reflected light is always found along the edge of an object and separates the darkness of the shadow edge from the darkness of the cast shadow.

5 **Full light:** This is the lightest area on the object, where the light is hitting the sphere at full strength.

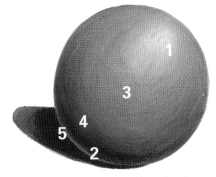

This sphere is done using Burnt Umber and Titanium White. It has a monochromatic color scheme.

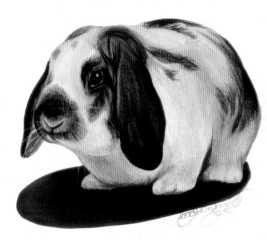

Compare this bunny to the sphere and you can see the similarities. Commit the five elements of shading to memory. They are essential to realistic painting.

Value Scale

I typically use a value scale like this to create my paintings. Value 1 represents the lightest value and value 5 represents the darkest.

basic techniques
Practice the Five Elements of Shading

Let's paint this sphere together using Ivory Black and Titanium White. Identify where the five elements of shading (see page 31) will be, and look at the value scale shown in step 1. Notice how the value scale with the brown tones on page 31 compares with the gray tones here. It is important to make the depth of tone for each swatch the same for both scales. For example, the value 3 brown tone should be the same value, or darkness, as the value 3 gray. If the brown scale were copied on a black-and-white photocopier, it should look the same as the scale on this page.

MATERIALS

paints
Ivory Black, Titanium White

brushes
no. 6 filbert, no. 4 round

other
mechanical pencil, ruler

1 Mix Your Colors
Value 5 is pure Ivory Black. Mix a very small amount of Titanium White with Ivory Black until you match the dark gray of value 4. When you are happy with your color, take some of the dark gray, and mix a little more Titanium White into that to create the halftone (value 3). Add some more white to that to create the light gray (value 2). Value 1 is pure Titanium White.

2 Draw the Circle
With a mechanical pencil, trace a perfect circle onto your canvas paper. Create a border box around the sphere with a ruler, then draw a horizontal line behind the sphere. This will represent a tabletop, and give the illusion of a background area.

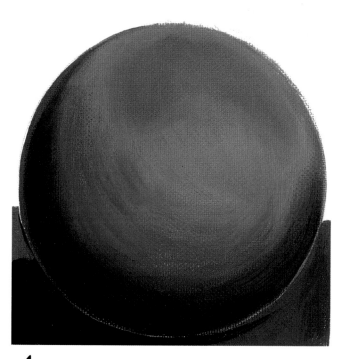

3 Paint the Base Colors

With a dark gray that matches 4 on your value scale, base in the tabletop with a no. 4 round. This brush is pointy so it can get into the corner and go around the curved surface easily. This deep gray will give you a foundation to build the rest of the painting on.

To paint the tabletop, begin with the darkest area first. In this case, it is under the sphere in the cast shadow. Use the Ivory Black full strength (5 on the value scale) to create the cast shadow over the dark gray. Use the same no. 4 round.

Switch to the no. 6 filbert, and fill in the entire sphere with a medium gray mixture. This should match 3 on the value scale. Be sure to completely fill in the sphere so that there is no canvas showing through.

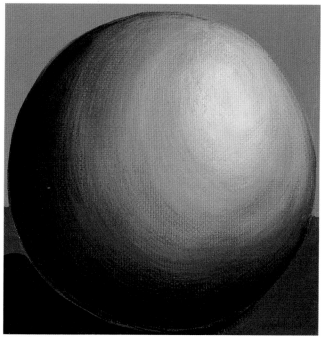

4 The Awkward Stage

With the value 4 dark gray mixture, apply the shadow edge of the sphere with a no. 6 filbert while the medium gray paint is still wet. The filbert will blend the tones together. Make sure the shadow is parallel to the edge of the sphere, allowing the two colors to blend. Allow the dark gray to show along the edge of the sphere, creating the reflected light.

While the paint is still wet, add some of the medium gray mixture above the dark gray. Blend the two using long rounded strokes that follow the contours of the sphere to create the halftone area. Continue blending until the tonal transitions are smooth.

5 Finish

With Titanium White, apply the full light area and blend it into the halftone using a no. 6 filbert. To make the light areas stand out, apply some of the medium gray behind the sphere to create the background. The light edge of the sphere contrasts against it.

This is not as easy as it looks, so please do not get frustrated. Remember, you can go over things as many times as you want. I often add some paint, softly reblending it into the paint that is already there. I can spend a lot of time trying to get it just right. This is all part of the challenge.

Complementary Color Spheres

Practice painting the monochromatic sphere from the previous exercise. It really is the foundation for everything else you'll paint. When you feel you've got it, try painting spheres in color.

Remember the five values you created on page 32? For spheres in color, the main color of your sphere is a 3 on the value scale. Mix the lighter values (1 and 2) by adding Titanium White. Mix the darker values (4 and 5) by adding the complement of the main color. As you learned on page 21, complements produce a pleasing grayed-down color, perfect for painting shadows.

Use Color Complements

Complementary colors are colors opposite each other on the color wheel (see page 17). Using complementary colors can help intensify other colors in your painting. For more on complements, see page 21.

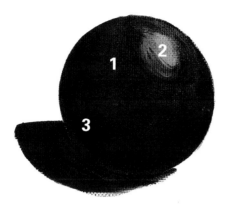

1 Cadmium Red Medium
2 Cadmium Red Medium mixed with Titanium White
3 Cadmium Red Medium mixed with green (Prussian Blue + Cadmium Yellow Medium)

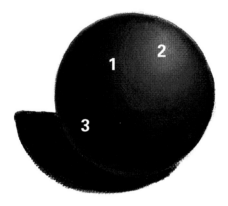

1 Green (Prussian Blue + Cadmium Yellow Medium)
2 Green mixed with Titanium White
3 Green mixed with Cadmium Red Medium

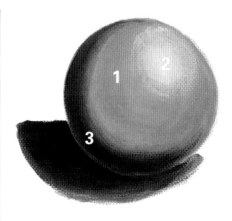

1 Cadmium Yellow Medium
2 Cadmium Yellow Medium mixed with Titanium White
3 Cadmium Yellow Medium mixed with violet (Alizarin Crimson + Prussian Blue)

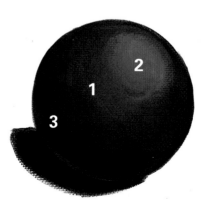

1 Prussian Blue
2 Prussian Blue mixed with Titanium White
3 Prussian Blue mixed with orange (Cadmium Yellow Medium + Cadmium Red Medium)

basic techniques
Find Spheres in Animal Shapes

This exercise will show you how to apply the previous lessons to an animal portrait. Look at the line drawing below; notice how the body of the cat is made up of many spheres. You can see the five elements of shading within the face, as well as in the overall form of the body.

The process for painting this cat is similar to painting a sphere. It just takes a lot more time and layers to paint an animal, due to the more complex shapes. Though you may feel the desire to skip the sphere exercises and dive right into "real" subject matter, please don't. Practice is essential to learning a new skill.

MATERIALS

paints
Burnt Umber, Cadmium Red Medium, Cadmium Yellow Medium, Ivory Black, Titanium White

brushes
no. 6 filbert, no. 2 round

1 Mix Your Colors
Mix a warm brown by adding a dab of Burnt Umber to Titanium White. Then add a touch of both Cadmium Red Medium and Cadmium Yellow Medium. Try to match the colors at right as closely as possible.

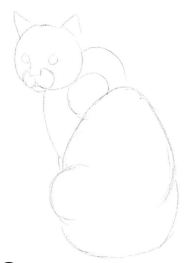

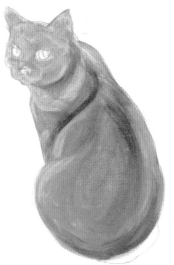

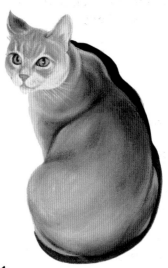

2 Draw the Cat
Draw the shape of the cat freehand on your canvas. Notice the many spheres that make up the cat's body.

Note

Don't be afraid to experiment with your color mixing. Try various colors by altering the amount of pigment you use. Color experimentation is an important part of the painting process.

3 Paint the Base Colors
Use warm brown to base in the overall color of the cat with a no. 6 filbert. With a no. 2 round, fill in the color of the eyes with a mixture of Cadmium Yellow Medium and a small amount of the original fur color. Fill in the pupils with Ivory Black. Outline the eyes with Burnt Umber. Fill in the nose with a pink mixture made with Titanium White, Cadmium Red Medium and a little Burnt Umber. Add more of the Burnt Umber to this mixture, and outline the nose.

4 Finish
Add the black background along the right side of the cat. This will help make the reflected light stand out. Use a no. 6 filbert to add the dark tones to the right side of the cat. Make these colors by adding more Burnt Umber and Cadmium Red Medium to the original mixture. If it becomes too pink, add more of the Cadmium Yellow Medium. This final process is not quick. Add light and dark colors until you have built the form.

basic techniques
Painting a Chinchilla

This is another good exercise for creating sphere-like shapes in an animal form. This chinchilla is one of my favorite examples. Not only is it adorable, it is extremely round, and the five elements of shading are clearly visible. The overall shape is easy to draw freehand. It is similar to building a snowman, stacking one sphere on top of another. The painting process is a bit more complex in this project. The textures in the fur are more visible, and the pose is more complicated due to the hands and feet.

Once you complete this project you will be ready to move on to more complicated subject matter. How do you go from drawing simple shapes such as these to more complex subjects with more detail? The following pages will explain my personal approach to drawing accurately.

MATERIALS

paints
Burnt Umber, Cadmium Red Medium, Ivory Black, Titanium White

brushes
no. 6 filbert, no. 4 flat, no. 2 round

1 Mix Your Colors
Create this warm gray by mixing a touch of Ivory Black with Titanium White. Add a touch of Burnt Umber.

2 Draw the Chinchilla
Draw the shape of the chinchilla on your canvas.

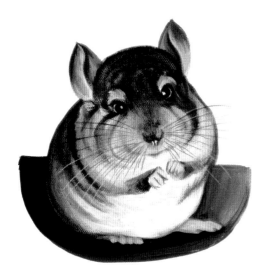

3 Paint the Base Colors
Base in the darker color of the chinchilla with the no. 6 filbert. Use the no. 2 round and Ivory Black to fill in and outline the eyes. Fill in the white area of the chinchilla with the no. 6 filbert.

4 Finish
Drybrush with a no. 4 flat to add texture to the chinchilla. Vary your colors by adding more Ivory Black and Titanium White for contrast. Create a flesh tone with Titanium White and a tiny amount of Cadmium Red Medium. Fill the hands in with the no. 2 round. With the no. 6 filbert, apply Ivory Black on the left and Burnt Umber on the right to add the shadow under the chinchilla.

Draw Using the Grid Method

To be a good painter, it's essential to learn some basic drawing skills. All paintings must have a firm foundation on which to build, so the shapes of the objects you are painting must be accurate.

I take my own reference photos to use in creating artwork. To accurately depict what I want to paint, I use the grid method to transfer shapes accurately from the photo to the canvas.

HOW THE GRID METHOD WORKS

The grid method is an excellent way to break down a complex subject into smaller, more manageable shapes.

1 Place a grid of squares over a reference photo. 1-inch (3cm) squares usually work well. If you have many small details to capture, you can place smaller squares over your photo.
2 Draw an identical grid on your canvas. The squares can be the same size, larger or smaller, but the grid on your canvas must have the same number of rows and columns as the one on the reference photo.
3 Lightly draw what you see within each square. This makes it easy to get the shapes right.

The Grid Method of Drawing

Have a copy shop make acetate overlays of your grid in various sizes. Then it is easy to take whatever size grid you need and tape it over any photo you want to paint. You can even number the individual boxes to help you keep track as you draw.

Puzzle Pieces

When using the grid method, remember this important idea: Everything you draw or paint should be viewed as a puzzle. All the pieces of the puzzle are nothing more than patterns of interlocking shapes of light and dark.

37

basic techniques
Grid Practice

Practice using the grid with this exercise. Use a regular piece of paper first to give you some experience before you draw on canvas paper. Focus on how the shapes fill each square of the grid. When you are happy with the outline, use an eraser to remove the grid lines. The paint will cover up the lines later, so don't worry if they smear.

You'll be able to complete this painting in a demonstration later in the book. For now, practice the drawing part, then put it aside. Look only at the shapes in one box at a time. Forget you are drawing an animal and see each box as a bunch of "nonsense" shapes.

Most of the projects in this book are started with the grid method. Practice all the drawing exercises first before you begin painting. Once you're proficient at drawing using the grid method, you'll find painting much easier.

MATERIALS

mechanical pencil
ruler
kneaded eraser

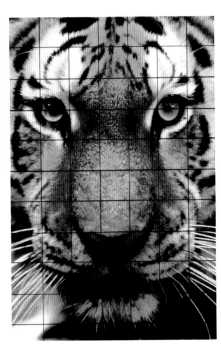

Reference Photo
A photograph of a tiger face with 1-inch (3cm) squares. Look for the "nonsense" shapes within each box.

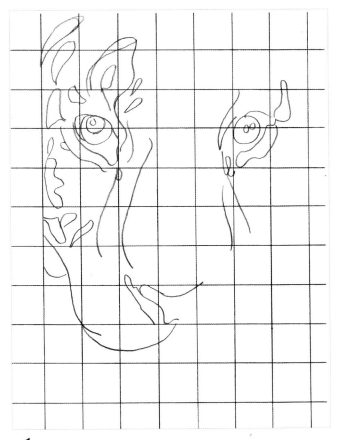

1 Lightly apply a grid of 1-inch (3cm) squares to your paper with a mechanical pencil. Using the grid as your guide, begin drawing the shapes you see, one box at a time. Go slowly, concentrate on one square at a time, and forget you are drawing a tiger.

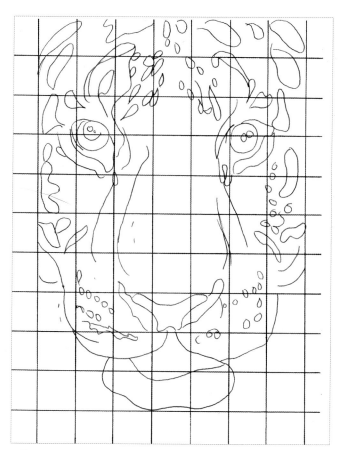

2 This is what your line drawing should look like when you are finished. Keep the small details to a minimum. Do not remove the grid lines until you are sure the drawing is accurate. All shapes should be corrected at this stage, before the painting process begins. We will complete this project later in the book (see page 98).

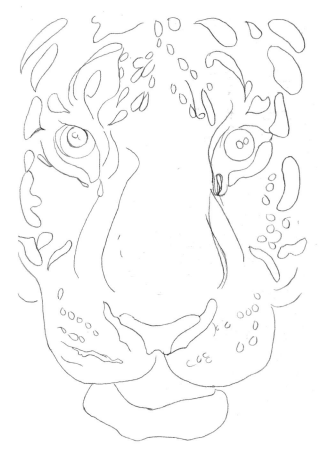

3 When you have accurately drawn the shape of the tiger's face, erase the grid with a kneaded eraser, leaving just the outline.

Use the Grid Method to Enlarge

The grid method is also a good way to enlarge your work. Let's take the same photo from the previous exercise, and do it a different way. Instead of using 1-inch (3cm) squares, place 2-inch (5cm) squares on your canvas. As you can see, the shapes are the same, but the larger scale makes them much bigger on your canvas. We now have a close-up look at things, and we will be able to do a nice drawing of just an eye. You could create the entire tiger face on a large scale, for instance on a wall, by making 5-inch (13cm) squares on your grid. Using the grid method allows you to accurately reduce or enlarge your image.

Easy Enlargement
The grid method is a good way to enlarge your work, allowing you to create closeups of your subjects and large-scale paintings.

More Grid Practice

Exercise your drawing skills to complete the following grid drawings. Remember, the better you can draw, the better your painting will be. You'll use all these drawings to complete the painting demonstrations to come.

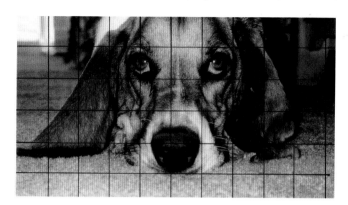

Reference Photo

It seems that everyone loves dogs. I receive more commissions for dog portraits than I do for portraits of children. This adorable basset hound belongs to a friend of mine and makes a very cute painting.

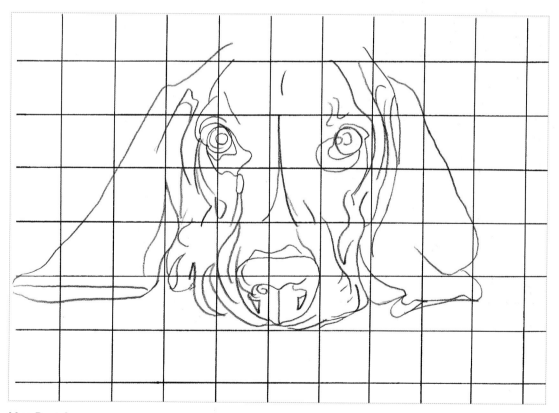

Line Drawing

Practice drawing this dog using the grid method, and put it aside for later. We will return to this project on page 71.

Reference Photo

Rabbits are fun little critters to paint. This one has a lot of texture and tones in its fur, so it will make a wonderful painting.

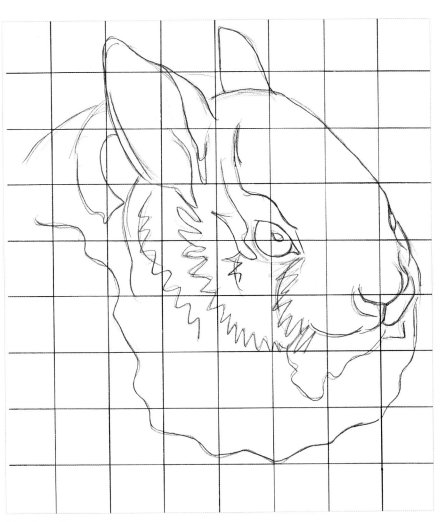

Line Drawing

Capture the line drawing using the grid method. We will return to this project on page 92.

Reference Photo

Horses are another favorite of artists. If you love horses, I have a book devoted to drawing them that will be a big help to you when painting these amazing animals.

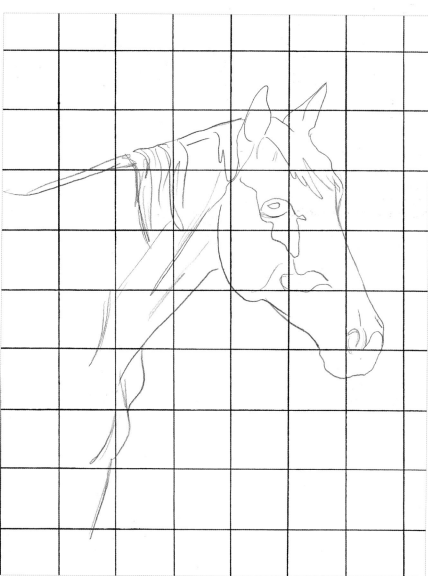

Line Drawing

Remember to simplify the details at this stage. The drawing should look like a map.

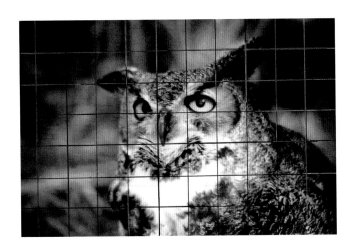

Reference Photo

Birds can make beautiful paintings. I love owls' huge, colorful eyes.

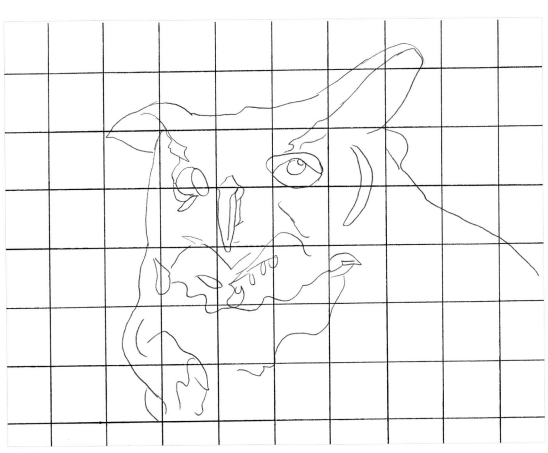

Line Drawing

When your drawing looks like this, you can remove your grid lines with the eraser. Be careful. Don't accidentally erase any of the details in the process. Use this drawing as a guide for the project on page 119.

chapter 4
Painting Animal Features

There are many concepts to remember when painting animals. I try to keep the process as simple and uncomplicated as possible so that it is fun for my students. While I could analyze the unique anatomical features of every animal, I think it is more important to focus on the traits they have in common.

I encourage you to look for the following three traits in each animal you observe: shape, color and texture. If you can describe these three traits, you will greatly simplify your subjects. It will make no difference whether you are creating a horse or a goldfish.

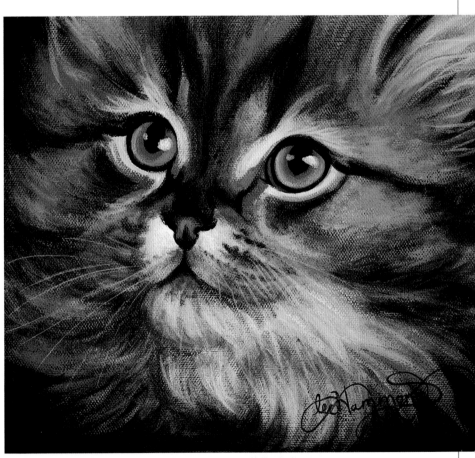

Focus on Attention-Grabbing Features
This closeup of a kitty is a good example of how the features of an animal can capture your attention. Cropping a painting to focus on the features makes a good composition with a lot of eye appeal. You can complete this project at the end of this chapter.

Kitty
7½" × 11"
(19cm × 28cm)

Painting Eyes

Eyes hold the essence of a portrait, whether it is of a person or an animal. The eyes connect the audience to the subject, and they often convey the personality or mood of the sitter. I think one of the biggest obstacles in creating animal eyes is the tendency to "humanize" them by showing white around the irises. This is a mistake. Rarely will you see white in an animal's eye. There are a few exceptions. Some dog breeds such as hounds have droopy eyes, and some white will show below the iris (see the basset hound project, page 71).

Remember the three common traits (shape, color and texture) that you should look for in every animal. These elements are important for rendering eyes.

The shape of the eye varies depending on the type of animal and on the angle from which it is observed. A front view allows you to see the eyes in their entirety. A side view is completely different. Close observation is necessary for capturing the shapes accurately.

Eyes are very colorful. While most animals have brown eyes, cats' and dogs' eyes are often green, blue or yellow. These bright colors are fun to paint.

Eyes are shiny and reflective and have a very smooth surface. You will often see bright catchlights and glare reflecting off their glassy surfaces. These elements can be quite challenging to paint, but the result is more than worth the effort.

These examples are details from some of the finished projects in the book. Notice that although these eyes belong to different animals, they share many similarities.

Owl

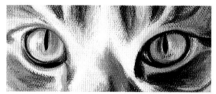

Cat

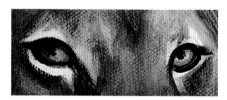

Lion

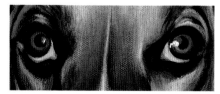

Dog

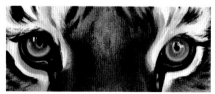

Tiger

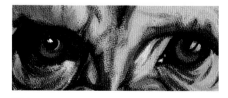

Chimpanzee

Find Shared Traits

All of these eyes are different in shape, but they have certain traits in common, such as texture and color. Eyes are very reflective and shiny, and most animals have brown eyes.

The Eye

This step-by-step exercise will give you some practice painting realistic animal eyes. The coloration is different in every case, so do not expect to have a standard color recipe. This example is a dog's eye. Try this project for practice. Before beginning to paint, lightly draw the outline of the eye on your canvas paper. Since this is a front view, the eye will appear as a perfect circle. (Use a template for greater accuracy.)

MATERIALS

paints
Burnt Umber, Cadmium Red Medium, Cadmium Yellow Medium, Ivory Black, Titanium White

brushes
no. 4 filbert, no. 3/0 round, no. 2 round

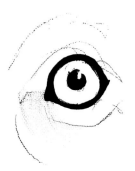

1 Begin With the Outlines

Use a no. 3/0 round to outline the iris and pupil with Ivory Black. Dilute the paint to make it easier to work with. Then fill in the pupil, leaving a small area for a catchlight.

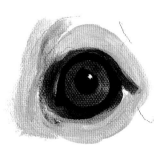

2 The Awkward Stage

Mix Titanium White with a dab of Burnt Umber and a touch of both Cadmium Red Medium and Cadmium Yellow Medium to create a reddish brown. Dilute the paint, and fill in the iris area with a no. 4 filbert. With the same brush, wash some of the paint around the outside edge of the eye. Make a light tan with a dab of Titanium White and a very small touch of both Cadmium Yellow Medium and Burnt Umber. Carefully add a hint of Cadmium Red Medium to warm it up. Apply a diluted solution of this color around the eye.

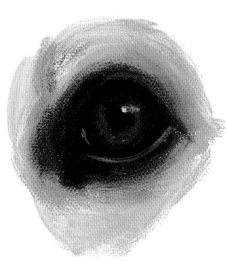

3 Finish

Go over the same areas with a thicker application of paint. This layering process allows you to add small details, somewhat like "drawing with paint."

Deepen the color of the iris with thicker applications of the same color mixtures. It will begin to look more realistic and colorful. Use a no. 2 round to make the pupil a bit smaller. With acrylics, a lighter color will cover up a darker color (even black) if the first layer is dry. Darken the outside edge of the iris with Burnt Umber. Allow the darker color to streak inward so that it replicates the patterns of the iris. Create a catchlight with a dot of Titanium White. Allow it to streak into the iris. Use a no. 3/0 round to add a small reflection along the edge below the eye and in the corner membrane.

To finish the eye, deepen the color of the fur around it with the no. 4 filbert. Start with the lighter color, then apply the darker brown, allowing it to soften into the lighter colors. Use the no. 4 filbert.

demonstration
The Set

Now that you have practiced painting the eye, it is important to learn how to put two eyes together. As you can see in the finished project, the eyes of this cat look very different from one another. This is due to the location of the light source. The eye on the right is more shadowed, which makes the color of the eye appear much deeper.

MATERIALS

paints
Burnt Umber, Cadmium Red Medium, Cadmium Yellow Medium, Ivory Black, Prussian Blue, Titanium White

brushes
no. 4 filbert, no. 2 round

1 Begin With the Outlines
Lightly draw the shapes of the eyes on your canvas paper. Apply diluted Cadmium Yellow Medium to the iris areas with a no. 2 round.

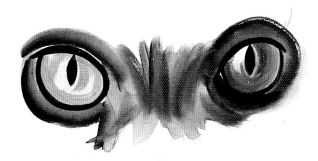

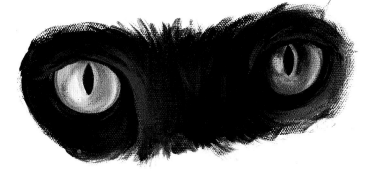

2 The Awkward Stage
Use the no. 2 round and diluted paint to add more color to the irises. Add a touch of Cadmium Red Medium to Cadmium Yellow Medium and apply the mixture to the outside edge of the irises. Mix a touch of Burnt Umber with some Cadmium Yellow Medium and apply it around the pupil, allowing a small edge of pure yellow to remain. The eye on the right is much darker. Add a touch of Ivory Black to some Cadmium Yellow Medium to create a nice olive green. Apply this mixture to the right eye as shown. Use a no. 4 filbert to apply diluted Ivory Black to the area around and between the eyes.

3 Finish
Finish the eye by going over the same areas with a thicker application of paint. To create the highlights on the black fur, add a touch of Titanium White and Prussian Blue to Ivory Black to create a blue-gray. Apply this mixture on top of the black.

Painting Mouths and Noses

These are examples of some noses and mouths taken from finished examples in the book. As you can see, each species has different and unique characteristics. It is important to study the animal you are painting, identifying the shapes that apply to its specific anatomy.

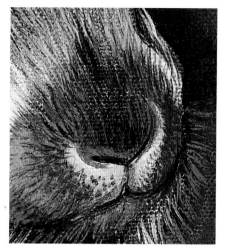

Rabbit

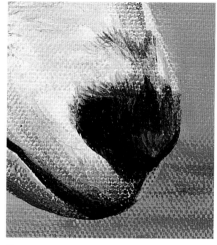

Goat

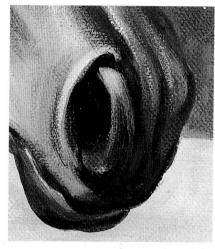

Horse

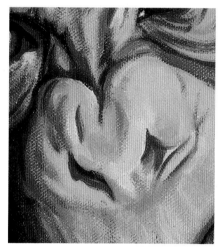

Chimpanzee

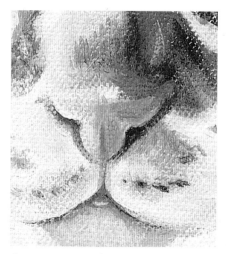

Cat

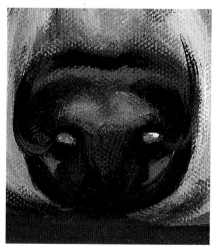

Dog

Look for Unique Shapes

Each species has uniquely shaped features. Study the animal you are painting closely. Look at the way the shape of the nose connects to the mouth. It's important to work on the two features together as you paint.

Front, Three-Quarter and Side Views

Here you can see how different the features of an animal appear when viewed from various angles. I am focusing on dogs and cats since they are so commonly portrayed in art.

DOGS

Although every dog nose is different, the basic anatomy remains the same. Look at how the edge of the nostril wraps around. You will see this characteristic in all dog noses.

You can also see from these examples, how the mouth and the nose are interconnected. It is important to work them together as you paint. The division line in the center of the nose always connects to the separation of the mouth and upper lip area.

CATS

Like the dog's nose, the cat's nose is divided down the center and connects to the division in the mouth. Cat features also change dramatically when viewed from different angles and poses. Notice how different the nose looks from the side.

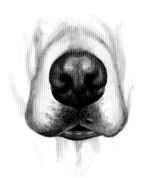 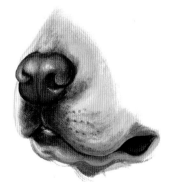

Front View
Look at the way the nose and mouth fit together. The center line of the nose connects to the center crease of the mouth.

Three-Quarter View
The side of the mouth is now more visible.

Side View
The edge of the nose and the way the nostril area wraps around is much more visible in this view.

Cat: Front and Side Views

The front view of this kitty shows the features in their entirety. The side view shows the features from a different perspective. It is important to study the shapes carefully. As you can see, a side view of an eye looks completely different from a front view. Careful observation is critical for good artwork. Always paint what you see, not what you remember.

Ears

All animals have unique ears. Whatever their shape, it is essential that you study the ears carefully and re-create them accurately.

Squirrel

Labrador

Ears can vary greatly from one dog breed to another. This is a Labrador ear, which is known for its long, turned down shape.

German Shepherd

This ear is from a German shepherd. It is very pointy and stands straight up.

Horse

Rabbit

Cat

Hair and Fur

Hair is another characteristic that varies greatly from one animal to the next. In the animal world, you will find both long and short hair, both straight and curly. As an artist, I find fur color and markings intriguing, and I love capturing them in my artwork.

Painting fur requires a lot of patience. It takes many, many layers to make the fur look real. The key to attractive animal paintings is to keep trying. Work through the awkward stage and take time to build up the layers of paint.

Tiger

Dog

Horse

Goat

Guinea Pig Fur

This little guy has very long fur. Use long brushstrokes to replicate the length and texture of the silky hair.

Cheetah Cub Fur

This little cheetah cub has short, spotted fur. Use short, quick brushstrokes to make the fur look textured. Brushstrokes must follow the direction in which the hairs grow. Quick strokes will make the lines taper and look more realistic.

demonstration
Cat Fur Fun

Depicting fur can be fun, but you must be patient. It is not a simple process and can require many, many layers to make it look realistic. Let's practice painting fur by creating the kitty on page 45. It has lots of long fur.

creating the kitty on page 45

MATERIALS

paints
Alizarin Crimson, Burnt Umber, Cadmium Red Medium, Cadmium Yellow Medium, Prussian Blue, Ivory Black, Titanium White

brushes
no. 4 filbert, no. 3/0 round, no. 2 round

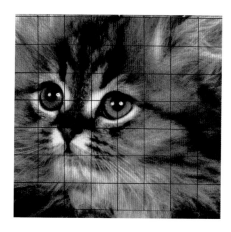

Reference Photo
Use this photo of a kitty as a reference.

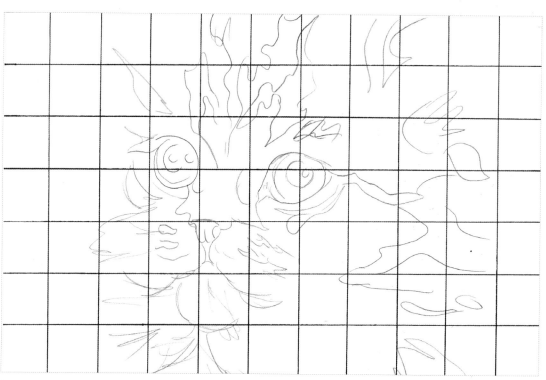

Line Drawing
Lightly draw a grid of 1-inch (3cm) squares on your canvas paper. Draw what you see inside each square until your drawing looks like this. Carefully remove the grid lines with a kneaded eraser, leaving behind the simple line drawing of the cat.

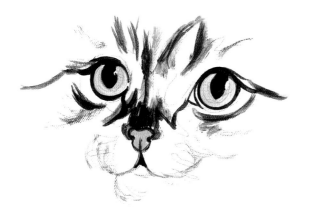

1 Begin With the Outlines

Mix a tiny amount of Ivory Black with some Cadmium Yellow Medium to create olive green. Apply a diluted layer with a no. 2 round to fill in the irises. With the same brush, fill in the pupil and outline the outside edges of the eyes with diluted Ivory Black. Make pink by mixing a tiny amount of Alizarin Crimson into Titanium White and fill in the nose. Outline the nose with Ivory Black.

Begin blocking in the markings on the face with the black and a no. 2 round.

2 The Awkward Stage

Make light tan with Titanium White, a touch of both Burnt Umber and Cadmium Red Medium, and a tiny touch of Ivory Black. Use a no. 4 filbert to base in the undertones of the fur with this mixture. Apply the brushstrokes in the same direction as the fur growth. Use the same brush to add some darker strokes of Burnt Umber over the basecoat. Go back to the eyes and add more color. Fill in the irises again with a thicker application of olive green. Mix Titanium White, Cadmium Yellow Medium and a tiny touch of Prussian Blue to create a green; apply this color around the pupil with a no. 2 round. Add a tiny bit of Burnt Umber to the olive green and apply it around the green, allowing a light edge to appear on the outside edge of the iris. Use a no. 2 round to create the catchlights with Titanium White. Make a deeper pink by adding more Alizarin Crimson to the pink mixture and apply it to the nose.

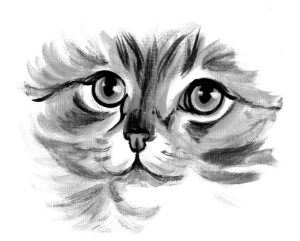

3 Finish

Using the no. 4 filbert, add layer after layer of brushstrokes. Alternate colors as you go. Use Burnt Umber for the darker patterns and Titanium White for the lighter ones. Thicker paint and the dry-brush technique will give the fur a textured appearance.

Use the no. 4 filbert to fill in the background with Ivory Black. Allow the brushstrokes and the lighter colors to streak into it. This makes the fur look wispy and realistic. Make the little dark dots at the base of the whiskers with Burnt Umber and a no. 2 round. To create the whiskers, apply a diluted solution of Titanium White with a no. 3/0 round using quick strokes.

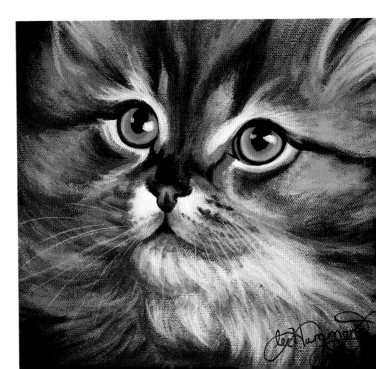

chapter 5
Painting Cats

I love drawing and painting all kinds of animals, but I really enjoy painting cats. I find their eyes incredible, with their rich colors and the intensity of their stare. In fact, of all animals, I think cats have the most beautiful eyes. I'm also captivated by the various markings they have in their fur. You can find cats in almost every color combination, and they all make beautiful paintings.

The following exercises will give you practice painting different types of cats, both large and small. Use this close-up study to analyze the shapes of the eyes and nose and to become familiar with their facial anatomy.

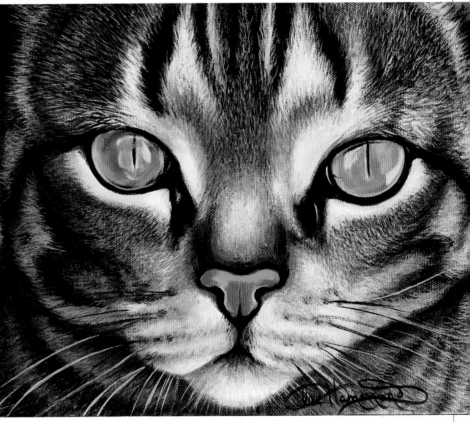

The Way Eyes Work
This example shows how shiny and colorful cat eyes can appear. Notice how the pupils of this kitty are mere slits. Bright light causes their pupils to close. If the light were less intense, the pupils would be larger and rounder, to allow more light to come in. Identify the shape of the pupil before you start to paint.

Kenla's Kitty
9" × 12"
(23cm × 30cm)

Monochromatic Cat

Sometimes, when encouraging my students to try something new, I find that they have an easier time if they start with a monochromatic color scheme. By painting in monotones, you can concentrate on the shapes, tones and contrasts without having to worry about color.

MATERIALS

paints
Ivory Black, Titanium White

brushes
no. 3 filbert, no. 3/0 round, no. 2 round

Reference Photo
Carefully study the shapes of the photograph, and draw what you see. Notice that the eyes are not circular like those of the cat on the previous page. Circles seen in perspective become ellipses.

Note

There is a lot of psychology in the drawing process. When we are trying to represent our subject from an angle rather than straight-on, we may subconsciously try to make the image too symmetrical. The reference photo for this project is a three-quarter view and needs to be drawn accordingly. The slight turn makes more of the nose visible on the right side of the center line than on the left.

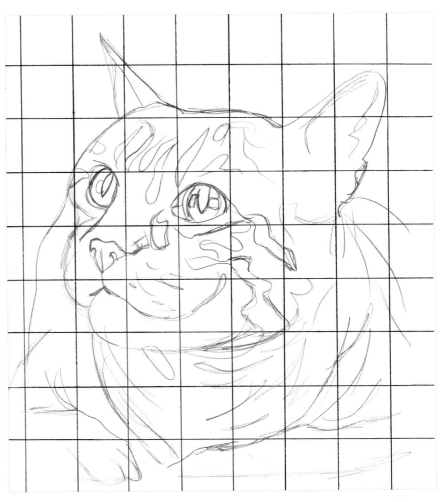

Line Drawing
Use the grid technique to create an accurate line drawing on your canvas paper. When you have the shapes drawn, remove the grid lines with your eraser, leaving the image behind.

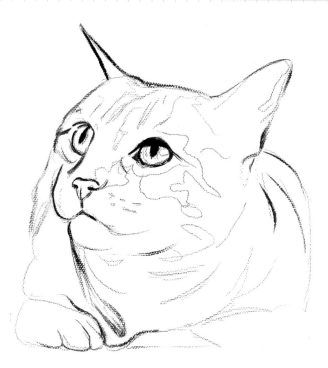

1 Begin With the Outlines

Use the no. 2 round and diluted Ivory Black to carefully outline the features such as the eyes, nose and ears. This captures the pencil drawing so that the shapes will not get lost while you paint.

2 Continue Adding Features

Further dilute the paint and continue adding the features of the cat with the no. 2 round. Capture the markings and stripes of the face, and lightly wash in the tone above and inside the nose.

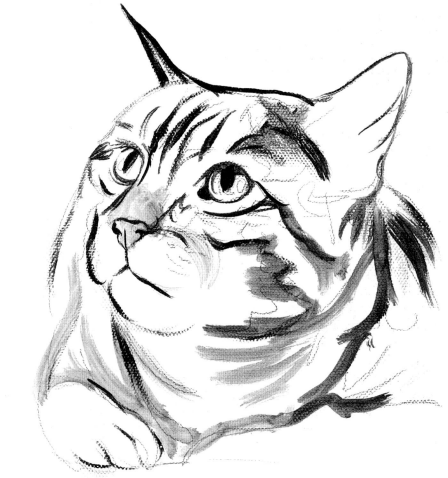

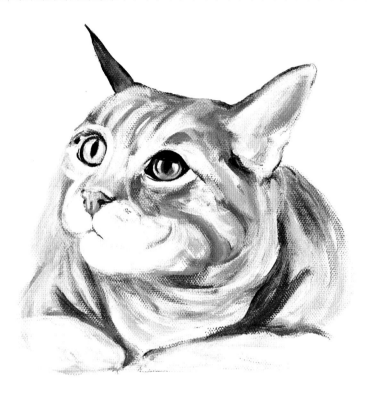

3 The Awkward Stage

Mix a light gray tone with Ivory Black and Titanium White. Use a no. 3 filbert to fill in most of the cat. Also use this color to fill in the iris. Continue adding details to the eye with various shades of gray and a no. 3/0 round. The eye on the right is deeper in color, with more patterns, so study it closely. Use Titanium White for the catchlights.

Add more Ivory Black to the paint mixture to create a medium-gray tone. Use this color and a no. 2 round to block in the patterns of the fur markings.

4 Finish

Finish the kitty by building up the fur with quick strokes. Make sure your strokes follow the direction of the fur growth, and alternate dark and light so they overlap one another. This stage can take a long time, so don't stop too soon. The more patient you are, the better your painting will be.

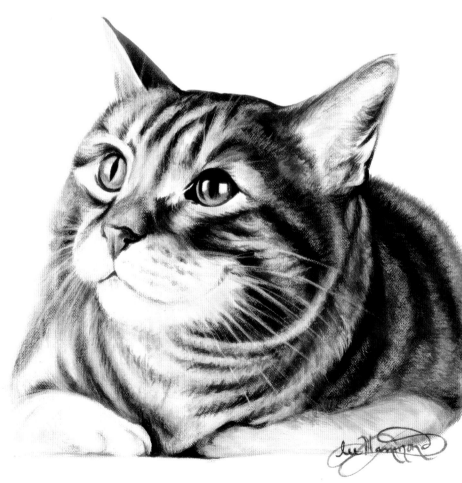

demonstration
Blue-Eyed Kitten

Few things are as cute as a kitten. They make adorable artwork. This kitten study is a fun project, and it is not difficult to do. This time we will include the entire body, longer fur and additional colors.

MATERIALS

paints
Burnt Umber, Ivory Black, Prussian Blue, Titanium White

brushes
no. 3 filbert, no. 6 filbert, no. 3/0 round, no. 2 round

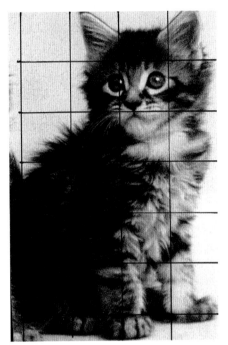

Reference Photo
A kitten's proportions are slightly different from those of a full-grown cat. The grid method will help you accurately capture those differences on your canvas paper.

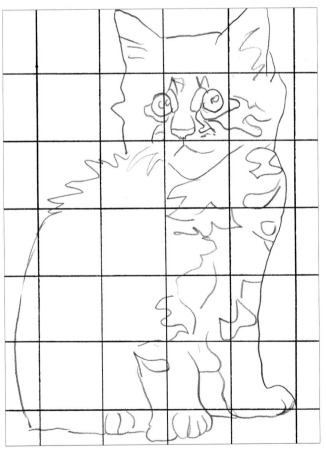

Line Drawing
When you have the shapes drawn accurately, your line drawing should look like this. Remove the grid lines with your eraser, leaving the image behind.

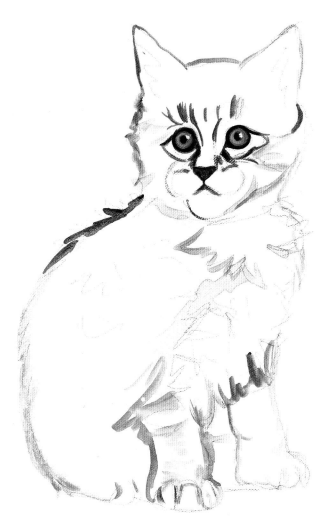

1 Begin With the Outlines

Use a no. 2 round and diluted Ivory Black to capture the shape of the kitten. Outline the edges of the eyes and nose. Create a blue-gray by mixing Titanium White with a touch of Ivory Black and a tiny bit of Prussian Blue. Be careful, because Prussian Blue is extremely potent; a tiny little bit will go a very long way. Use the no. 3/0 round to fill in the color of the eyes with this mixture. Allow a small white area to remain for the catchlight. Fill in the little nose with a diluted mixture of Ivory Black and Burnt Umber, using the no. 3/0 round.

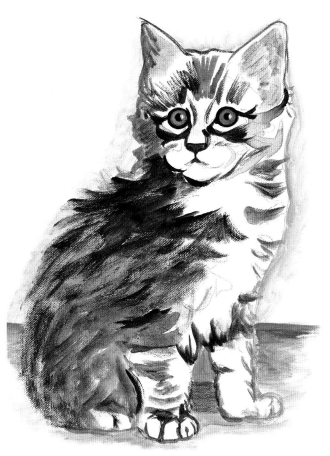

2 The Awkward Stage

Block in the fur of the kitten with diluted Ivory Black and a no. 3 filbert. Your brushstrokes should follow the fur's direction and natural patterns. Even at this stage, the texture and depth of the fur is being created. Use diluted Prussian Blue and a no. 3 filbert to wash in the background color surrounding the kitten. Create a line across the page to represent a horizon line. This line separates the background from the foreground and creates the illusion of a floor. Fill in this area with a diluted mixture of Ivory Black and Prussian Blue. With diluted Burnt Umber and a no. 2 round, fill in the inside of the ears.

3 Finish

Apply thicker layers of paint to finish. Rather than sticking to just Ivory Black and Titanium White, which would result in a kitten in shades of gray, I added a touch of Burnt Umber to the color mixtures. This addition offers a subtle, warm brown coloration to the fur.

Fill in the darker areas of the body first, using a no. 3 filbert and a mixture of Ivory Black and Burnt Umber. Add small amounts of Titanium White to this mixture to create several light and medium shades of gray. Use these colors and the no. 3 filbert to paint the lighter patterns in the fur. Overlap the light on the dark colors to create the illusion of long fur. Switch to the no. 2 round and continue building the fur layers, overlapping light and dark strokes for a more realistic effect. Look at the chest area to see how I developed the fur layers. Make sure to capture all of the patterns in the face, particularly around the eyes.

Use the no. 2 round to paint the feet. View them as patterns of light and dark shapes. Add the hair inside the ears. Make sure to use very quick strokes so that they taper at the ends and look like hair. With the no. 3/0 round and diluted Titanium White, add the whiskers. They'll stand out against the darker fur.

To finish the background, apply a thicker layer of Prussian Blue and Titanium White. Use the no. 6 filbert and apply the paint in a circular, swirling motion. Make the color deeper near the kitten. Add more Titanium White to the mixture and make the background color lighter as it moves farther outward, away from the kitten.

Finish the foreground with a thicker application of gray, using the no. 6 filbert. The subtle blue tones from the original wash should still show through on the right. Use Ivory Black to create the shadows under the kitty. As you work away from the kitten, add some Burnt Umber to the black to give the edge of the shadow a warm glow. For the shadows on the left side of the kitten, add some Ivory Black and Prussian Blue to the mixture and use circular brushstrokes for a hint of texture. This method allows you to gradually lighten the tones as they get farther away from the kitten.

demonstration
Cat Closeup

Burnie is a permanent fixture in my studio. He is a true "art cat." He likes to put his paws in students' paint palettes and add to their paintings. His unusual and bold personality shows in the photos we take of him. This example makes a great painting with vibrant colors.

MATERIALS

paints
Alizarin Crimson, Burnt Umber, Cadmium Red Medium, Cadmium Yellow Medium, Ivory Black, Prussian Blue, Titanium White

brushes
no. 4 filbert, no. 6 filbert, no. 3/0 round, no. 2 round

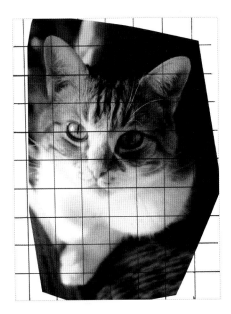

Reference Photo
I love the rich, golden coloration and the way that Burnie's eyes capture all of the attention in this photo.

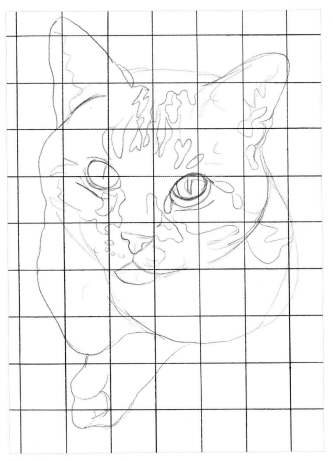

Line Drawing
Use the grid method to capture the shapes of Burnie's face on your canvas paper. When you are sure of the accuracy, remove the pencil lines with an eraser.

3 Finish

Apply thicker layers of paint to finish. Rather than sticking to just Ivory Black and Titanium White, which would result in a kitten in shades of gray, I added a touch of Burnt Umber to the color mixtures. This addition offers a subtle, warm brown coloration to the fur.

Fill in the darker areas of the body first, using a no. 3 filbert and a mixture of Ivory Black and Burnt Umber. Add small amounts of Titanium White to this mixture to create several light and medium shades of gray. Use these colors and the no. 3 filbert to paint the lighter patterns in the fur. Overlap the light on the dark colors to create the illusion of long fur. Switch to the no. 2 round and continue building the fur layers, overlapping light and dark strokes for a more realistic effect. Look at the chest area to see how I developed the fur layers. Make sure to capture all of the patterns in the face, particularly around the eyes.

Use the no. 2 round to paint the feet. View them as patterns of light and dark shapes. Add the hair inside the ears. Make sure to use very quick strokes so that they taper at the ends and look like hair. With the no. 3/0 round and diluted Titanium White, add the whiskers. They'll stand out against the darker fur.

To finish the background, apply a thicker layer of Prussian Blue and Titanium White. Use the no. 6 filbert and apply the paint in a circular, swirling motion. Make the color deeper near the kitten. Add more Titanium White to the mixture and make the background color lighter as it moves farther outward, away from the kitten.

Finish the foreground with a thicker application of gray, using the no. 6 filbert. The subtle blue tones from the original wash should still show through on the right. Use Ivory Black to create the shadows under the kitty. As you work away from the kitten, add some Burnt Umber to the black to give the edge of the shadow a warm glow. For the shadows on the left side of the kitten, add some Ivory Black and Prussian Blue to the mixture and use circular brushstrokes for a hint of texture. This method allows you to gradually lighten the tones as they get farther away from the kitten.

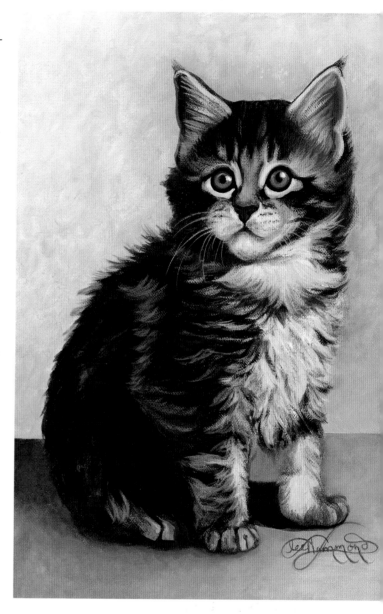

Cat Closeup

Burnie is a permanent fixture in my studio. He is a true "art cat." He likes to put his paws in students' paint palettes and add to their paintings. His unusual and bold personality shows in the photos we take of him. This example makes a great painting with vibrant colors.

MATERIALS

paints
Alizarin Crimson, Burnt Umber, Cadmium Red Medium, Cadmium Yellow Medium, Ivory Black, Prussian Blue, Titanium White

brushes
no. 4 filbert, no. 6 filbert, no. 3/0 round, no. 2 round

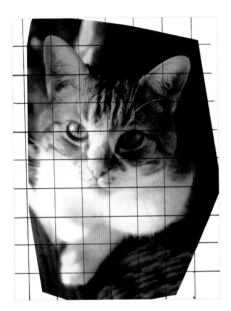

Reference Photo
I love the rich, golden coloration and the way that Burnie's eyes capture all of the attention in this photo.

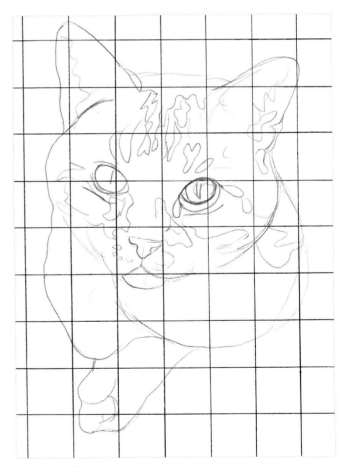

Line Drawing
Use the grid method to capture the shapes of Burnie's face on your canvas paper. When you are sure of the accuracy, remove the pencil lines with an eraser.

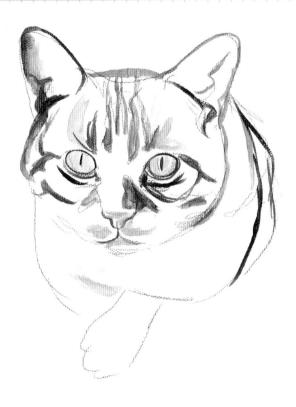

1 Begin With the Outlines

Create a light olive green by mixing a tiny amount of Ivory Black with some Cadmium Yellow Medium. Use the no. 2 round to apply a diluted solution of this color to the irises. Use the no. 3/0 round and Ivory Black to fill in the slit of the pupil and carefully outline the eye.

Use the no. 2 round to go over the pencil lines with diluted Burnt Umber. Add a touch of Titanium White and Cadmium Red Medium to the Burnt Umber, and fill in the nose and mouth area.

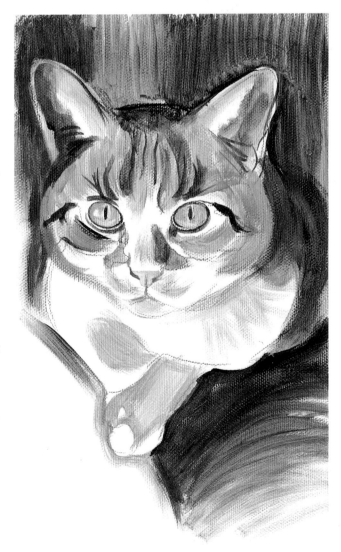

2 The Awkward Stage

Continue to develop the colors of the eyes. Add more Cadmium Yellow Medium to the olive green mixture and apply it with the no. 3/0 round. Add the catchlights with Titanium White.

Most of Burnie's fur is warm-colored, with a lot of orange. To create his coloration, mix Burnt Umber with some Titanium White and a touch of both Cadmium Red Medium and Cadmium Yellow Medium. Apply this color with a no. 2 round. For the darker areas, such as the markings on the forehead and back, add some Alizarin Crimson and Ivory Black.

The shadows on his chest, front leg and paw are the same color used for the nose and mouth in step 1. Although his fur is "white" here, it reflects the other colors. Block in these colors as shown, using the no. 2 round. Keep the paint diluted.

The background is made of the same colors as the cat. Apply it with vertical brushstrokes, using the no. 4 filbert. Keep the colors darker in each corner and a golden yellow in the middle, above the cat's head. For the cushion in the foreground, create a mixture of Ivory Black and Prussian Blue and apply it with the no. 4 filbert. Curve the brushstrokes to make the surface appear rounded.

3 Finish

Apply thicker layers of paint to finish. Burnie's fur is made up of many shades of golden brown, with some areas more yellow, and others redder. For the warmer tones, use Cadmium Yellow Medium and Cadmium Red Medium. For deeper shades, use Cadmium Yellow Medium and Alizarin Crimson. You can deepen these colors by adding Burnt Umber, which will add browner tones.

Enhance the colors of the eyes with a mixture of Prussian Blue and Cadmium Yellow Medium. Apply the paint carefully with the no. 3/0 round. It takes many layers to bring a painting to this level. Refer to the illustration to help you as you build up the color brushstroke by brushstroke.

Use a no. 6 filbert to create the illusion of the rungs and the back of the chair on the left. Put down the dark colors first, then add the highlights. Use the same approach to create the chair cushion: the dark blue first, then the lighter blue streaks. To create a warm glow in the background, blend thick mixtures of brown, yellow and red.

The final stages are for the tiny stuff, like the small hairs inside the ears, the hairs that overlap the background and the whiskers. Add these details with the no. 3/0 round.

chapter 6
Painting Dogs

When I am commissioned to create a portrait of a pet, chances are it will be of someone's dog. We're totally in love with our furry "best friends." Dogs appear in artwork dating back to prehistoric times. Serious or amusing, dog portraits capture our attention and our hearts. This chapter will give you some practice painting various types of dogs, giving you the necessary experience to create amazing dog portraits.

Serious or Silly?
Sometimes you will create a serious portrait; other times something silly, such as this painting of a miniature Pomeranian.

Just Hangin' Around
14" × 11"
(36cm × 28cm)

demonstration
Monochromatic Dog

Once again, I believe it is important to start slowly and use a monochromatic color scheme for your first dog portrait. This demo will give you practice capturing the features, seeing them as shapes and tones, without fixating on the colors. Follow the step-by-step instructions to create this cute spaniel.

Reference Photo
This spaniel's fur is long and curly. Use the grid method to accurately capture the shapes on your canvas paper.

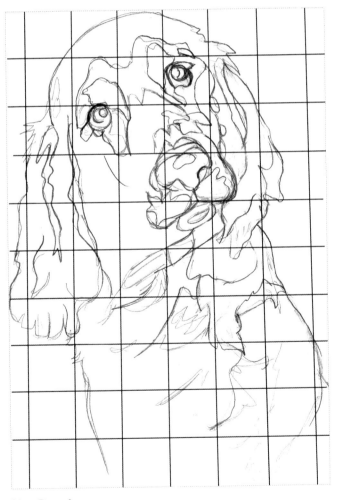

Line Drawing
When your drawing is complete, erase the grid lines

1 Begin With the Outlines

With a no. 1 round, outline the eyes of the dog with Ivory Black. Fill in the pupil, leaving a small area for the catchlight. A catchlight appears in the iris as well as in the pupil. Switch to a no. 2 round and start filling in the darkest areas of the dog: along the top of the head and in the neck area. Leave the shape of the collar alone.

With a no. 1 round, add strokes to the ears. These brushstrokes should follow the direction the fur is growing, curving with the waves of the fur. Fill in the nose with the no. 1 round. Leave the highlight areas of the eyes uncovered.

2 The Awkward Stage

Continue building the tones of the dog by adding more Ivory Black with a no. 2 round. The brushstrokes should always follow the direction the fur, even if the area fills in solidly. Should brushstrokes show, they must be consistent with the fur's direction. Straight strokes would make the dog's form look flat.

Create a medium gray by mixing Ivory Black and Titanium White. Use this color to fill in the iris of the eyes, the area above and below the eyes, and the area of the muzzle around the nose. Use the same color to fill in the collar and add some waves to the areas of the ears.

3 Finish

This step is about creating volume and dimension in the fur. In the previous step, I deliberately left some of the canvas uncovered in the highlight areas. Now you will layer medium gray and Titanium White into these highlight areas to make the fur look full. Using the no. 1 round, add the medium gray in quick, curved strokes to replicate the shape of the waves. To make the waves look shiny, add some white highlights on top of the gray using the same quick strokes. Can you see how this layering technique makes the fur look thick and full?

demonstration
Puppy Closeup

This little puppy face will give you practice applying subtle color. In the previous project, the many layers of curls on the black dog were much more defined. The patterns of light and dark were separated and relatively easy to create. Although it may look easier, this project is more challenging. The smoother texture of the fur and the even distribution of light in this painting are more difficult to replicate.

MATERIALS

paints
Burnt Umber, Cadmium Red Medium, Ivory Black, Prussian Blue, Titanium White

brushes
no. 3 filbert, no. 2 flat, no. 3/0 round, no. 2 round

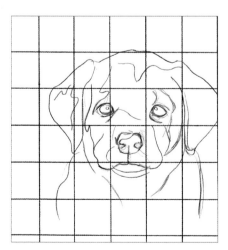

Reference Photo
The smooth fur of this Labrador retriever puppy shows very little texture, and the light distribution is more even. This makes the tones very subtle; they blend and fade into one another very gradually. The blue tones of the background reflect on the light-colored fur.

Line Drawing
When you are sure of the accuracy of your drawing, carefully remove the grid lines with your kneaded eraser.

1 Begin With the Outlines
Start by outlining the eyes and nose with Ivory Black, using a no. 2 round. Place the pupil in the eye. Remember to leave a small dot of white on the border of the pupil and iris for the catchlight.

Mix some Titanium White into Ivory Black to make a dark gray; use a no. 2 round to fill in the nose, leaving the upper part white. Mix Burnt Umber with a touch of Ivory Black, then dilute it. Use this diluted mixture to outline the edges of the face with the no. 2 round, and add some around the eyes and in the lower lip area.

2 The Awkward Stage

Take the dark gray color you used for the nose and fill in the irises. These are small areas, so use the no. 3/0 round. Don't fill in the catchlights.

Take the diluted Burnt Umber and Ivory Black mixture from step 1, and lay a wash of this color into the ears, mouth area and neck.

Mix Ivory Black and a tiny bit of Prussian Blue. Apply a diluted solution of this mixture in swirling strokes to the background with a no. 3 filbert.

Further dilute the blue mixture and apply it to the face with a no. 2 round. You can see this bluish color in the middle of the forehead and on the right side of the muzzle, mouth and neck.

3 Finish

Apply thicker layers of paint to finish. Add Titanium White to the color mixtures during this layering stage to make the colors more opaque.

With a no. 2 round, apply Titanium White to the areas we had previously left blank. Allow the white to gently soften into the colors you have already applied. Mix Burnt Umber and a tiny bit of Ivory Black into some Titanium White and apply it to the ears. Add some more Burnt Umber and apply it to the area below the nose.

To create the reddish brown edges around the eyes, ears, face, chin and neck, mix Titanium White with Burnt Umber and Cadmium Red Medium. Apply this color with a no. 2 round. Can you see the five elements of shading on the right side of the face? These elements create the contours of the face. There's an edge of reflected light along the right side of the face, under the ear. These effects are subtle, but they're important for achieving realism.

To finish the puppy, scrub in the highlights of Titanium White on top of the darker colors, using a no. 2 flat and the dry-brush method. Deepen the background color with a thicker application of the same dark mixture used in step 2. Use a no. 3 filbert to scrub in a circular motion. Reflect the background color on the forehead; lighten it with Titanium White and scrub it in with a no. 2 flat. Mix Ivory Black and Titanium White to create a light gray, and add some small dots to the muzzle with a no. 3/0 round. Add the whiskers with the same brush and Titanium White. Use quick strokes, lifting at the end of each stroke so the whiskers taper.

demonstration
Basset Hound

Dogs have extremely soulful eyes, and no other breed has more soul than a basset hound. My friend June rescues basset hounds and has provided me with many adorable photos for use in my books.

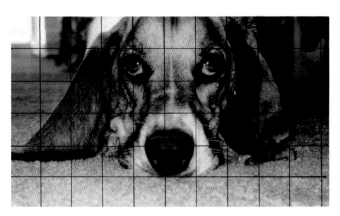

Reference Photo

This pose of June's dog, Sophie, is a great one to paint.

Photo by June Sakagawa

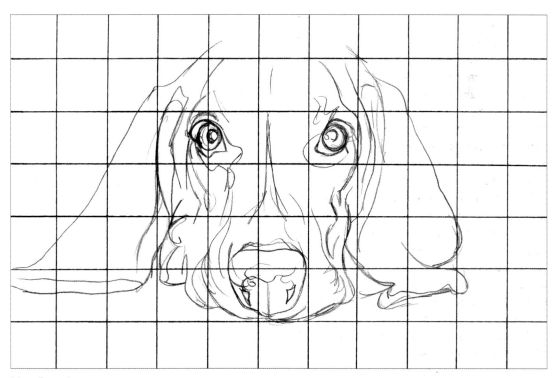

Line Drawing

Make sure your drawing is accurate before you erase the grid lines. This is the same line drawing that we worked on in the exercise on page 41.

1 Begin With the Outlines

With the no. 2 round, outline the features and edges with Burnt Umber. Fill in the irises, leaving a small spot of white for the catchlight.

Use a no. 6 filbert and diluted Burnt Umber to fill in the ears. Apply some of this solution between the eyes as well. Fill in the nose with diluted Ivory Black. Apply this color to the sides of the muzzle and above the eyes.

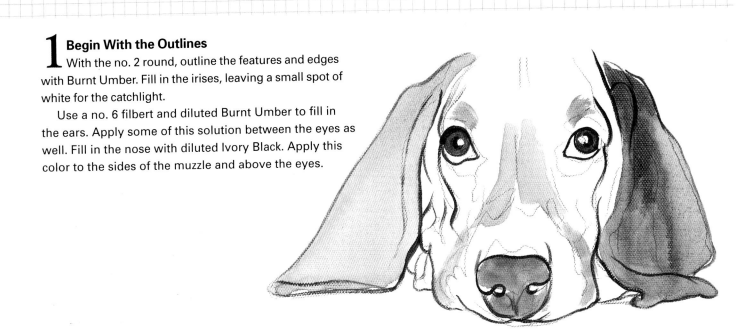

2 The Awkward Stage

Using thicker layers of the same colors, fill in the dog's entire face, using the no. 4 filbert. Leave the muzzle area white. Mix a light gray from Ivory Black and Titanium White, then apply it to the muzzle area above the nose with the no. 2 round. Use this mixture to fill in the little areas under the dog (these will become the paws).

Create a horizon line that will distinguish the background from the middle ground and foreground. Fill in the background with diluted Prussian Blue, using the no. 4 filbert. Create the foreground and middle ground the same way, using a diluted mixture of Alizarin Crimson with a hint of Prussian Blue.

Make pink with Cadmium Red Medium and Titanium White, and use a no. 2 round to add a touch to the eye membrane. Although most animals don't show the white beneath the iris, basset hounds do, so apply Titanium White in this area. To further emphasize the irises, outline them with Ivory Black using the no. 2 round. Fill in the nose and the dark area around the eyes with black as well. Add a white highlight on the top of the nose.

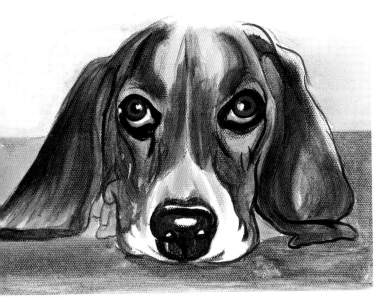

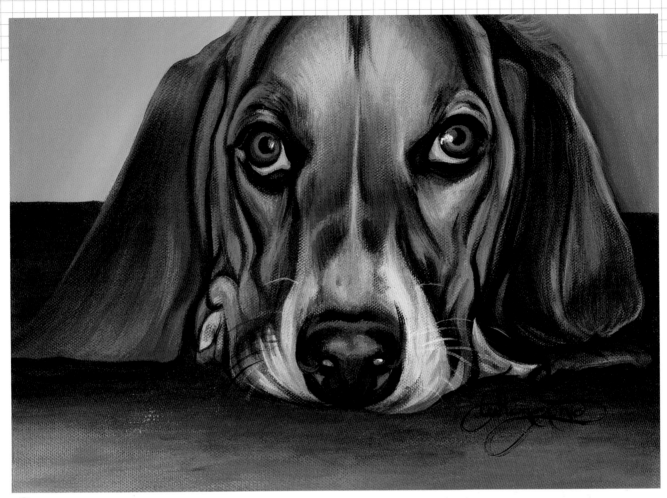

3 Finish

Apply thicker layers of color to finish. Make the brown tones by mixing Burnt Umber with Titanium White. Adding white makes the mixture more opaque. Adjust the mixture as needed by adding other colors such as Cadmium Red Medium or Cadmium Yellow Medium.

If you look closely at the painting, you can see where the lighter colors have been applied on top of darker layers. This makes the dog's coat look reflective. Notice the blue reflecting off the nose and ears. Use the no. 4 filbert to add these reflected colors, starting with the darker tones. Add the lighter colors last.

Intensify the colors of the background and foreground. Use a mixture of Titanium White, Prussian Blue and a touch of Cadmium Yellow Medium for the left side background. Add a touch of Alizarin Crimson to deepen the mixture and apply to the right side background.

Make the foreground lighter in the front, darkening toward the middle ground. Start with the lighter color, a mixture of Alizarin Crimson, Titanium White and a tiny touch of Prussian Blue. Then add more Alizarin Crimson and Prussian Blue to deepen the color for the middle ground. Use the no. 6 filbert and long even strokes to blend the paint.

Finally, add the whiskers, using the no. 3/0 round and quick strokes that taper toward the ends. There are both white and black whiskers.

demonstration
German Shepherd

This portrait of a German shepherd will give you practice painting large ears and an open mouth. While a dog's teeth are not always inviting, it is important to paint them accurately. A lot of personality is expressed through the mouth. You can tell from the open mouth and sparkling eyes that this is one happy dog.

MATERIALS

paints
Alizarin Crimson, Burnt Umber, Cadmium Red Medium, Cadmium Yellow Medium, Ivory Black, Prussian Blue, Titanium White

brushes
no. 3 filbert, no. 4 filbert, no. 6 filbert, no. 2 round

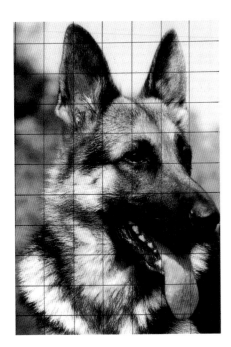

Reference Photo
Use the grid method to help you capture this German shepherd on your canvas paper.

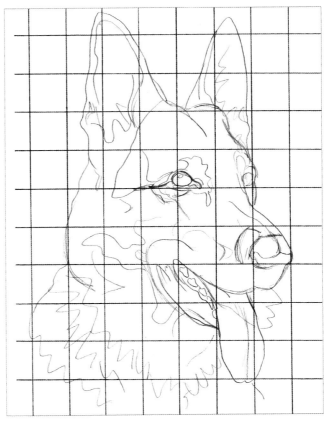

Line Drawing
When you have the shapes drawn accurately, your line drawing should look like this. Remove the grid lines with your eraser, leaving the image behind.

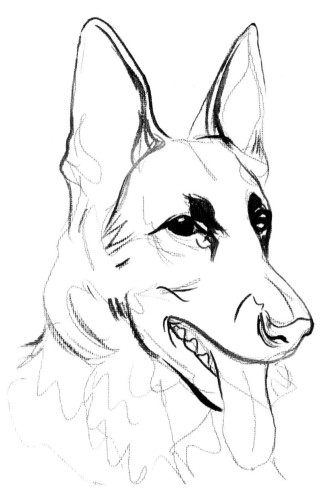

1 Begin With the Outlines

Use the no. 2 round and Ivory Black to go over some of the pencil lines. Outline the shapes of the ears.

Capture the shapes of the eyes, and fill in the pupil and iris area. Outline the nose and mouth, paying particular attention to the shapes of the teeth.

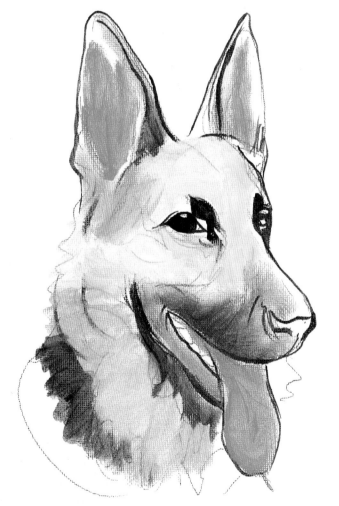

2 Start Filling in Color

Use the no. 3 filbert to block in the face and neck area with diluted Cadmium Yellow Medium. Create pink with Alizarin Crimson and Titanium White. Dilute this mixture and apply it to the tongue and the inside of the ears. Use the no. 2 round to apply some of the pink to the lip area.

With the no. 2 round and diluted Ivory Black, fill in the edges of the ears and the muzzle. Add some diluted Ivory Black underneath the jaw. Mix some Burnt Umber with the Ivory Black. Apply this mixture to the collar area of the fur. The portrait should look like a watercolor painting at this stage.

3 The Awkward Stage

Intensify the colors, using a thicker application of paint. Although the paint is thicker, it should still be somewhat transparent at this stage. Mix an orangey-yellow by adding a touch of Cadmium Red Medium to Cadmium Yellow Medium. Use the no. 2 round to apply this color to the face and the fur on the neck.

With the no. 3 filbert, apply diluted Burnt Umber to the fur on the neck, allowing the brushstrokes to follow the fur direction. Add some Ivory Black fur to the area below the tongue, paying attention to the direction of the fur growth.

Using a no. 2 round, deepen the black areas inside the ears, around the eyes and in the nose and mouth. Continue building the tongue color layers. There is a shadow that cuts across directly under the upper lip and continues down the right side. Create this shade with Cadmium Red Medium and a touch of Burnt Umber.

4 Finish

Make the background color with Titanium White, a dab of Cadmium Yellow Medium and a touch of Prussian Blue. Using the no. 4 filbert, thickly apply the background color in a swirling, circular motion. The color at the top of the background has more white and less yellow. Make the lower portion greener by decreasing the Titanium White and increasing the Cadmium Yellow Medium and Prussian Blue. Swirl the colors so that they fade into one another.

Apply a thicker layer of paint to intensify the colors of the German shepherd. Use the no. 2 round and allow the brushstrokes to create the texture of the fur, paying attention to its growth direction. Layer until the fur looks fluffy.

The mouth area is crucial to the painting. Don't make the teeth pure white; they're more yellow in color. Notice the patterns of color in the lips and gums. With the no. 2 round, go over the previously applied pink with Ivory Black. Make the shadows and highlights on the tongue more pronounced. Use the Cadmium Red Medium/Burnt Umber mixture from step 3 for the shadows. Highlight the top of the nose with Titanium White, and add some white fur under the neck.

demonstration
Studio Dog

The reference photo for this painting of Kimber was taken in my studio. (All of the animals sleep in there when I'm working.) The lighting is dim, indoor lighting with a lot of reflected color from the background. The blue tones of the background are beautiful reflecting off the edges of the dog and the shiny surface of the floor.

Reference Photo
Use the grid method to help you draw the shapes on your canvas paper.

Line Drawing
When you're sure of the accuracy of your shapes, carefully erase the grid lines with a kneaded eraser.

1 Begin With the Outlines
With a no. 2 round and Ivory Black, carefully outline the eyes, nose, mouth and the area under the ear. Dilute the paint to fill in the collar, the top of the mouth and the area underneath the dog, where she touches the floor.

Continue using the no. 2 round to lay in a wash of diluted Prussian Blue in the background. Streak some diluted Burnt Umber below the dog, and add some of the light blue below that.

2 The Awkward Stage

Block in the color of the dog, paying attention to the patterns of light and dark. Use Burnt Umber to paint the darker areas, such as the ears, neck and underside of the legs. Paint the lighter areas with a mixture of Burnt Umber, Titanium White and a touch of Cadmium Red Medium. Apply these colors with a no. 4 filbert. Pay attention to the direction of your brushstrokes; they're important for creating the contours of the dog. Streak these two colors onto the floor below the dog.

Make a thick mixture of Prussian Blue and Titanium White. Fill in the background with smooth strokes using a no. 6 filbert. Work quickly to prevent streaks. Pull this light blue down into the foreground's brown tones to create the shiny quality of the wood floor.

3 Finish

Apply thicker layers of paint to finish. First use the same colors from step 2 to complete the background, making sure it's smooth. Use a no. 4 filbert and a mixture of Burnt Umber, Titanium White and a touch of both Cadmium Red Medium and Cadmium Yellow Medium to paint the lighter areas of fur. Use less Cadmium Yellow Medium in the mixture for the darker areas. For the darkest areas, add more Burnt Umber. Once the colors are blended, add the light blue from step 2 to the edges of the dog, the chest and the face, particularly on the nose and the edges of the lips.

Finish the floor by blending the color used in Kimber's fur with the no. 4 filbert and horizontal strokes. Streak in more light blue. Create a mirror image of the ear on the floor with the reddish brown color.

chapter 7
Painting Horses
and Other Barn Animals

Another favorite animal commonly featured in artwork is the horse. I have an entire drawing book devoted to this graceful creature.

Horses have been depicted in artwork dating back to the cave paintings of prehistoric times. Their sleek, muscular bodies can make a great nature study. Their soft, gentle faces also can be used to create beautiful portraits, as seen here.

The farm has many other animals that are just as fun to paint. Although painting a cow or a goat may not seem traditional, many of the Old Masters depicted cattle in their work. They make very interesting subjects. The following projects will give you practice creating some common barnyard animals.

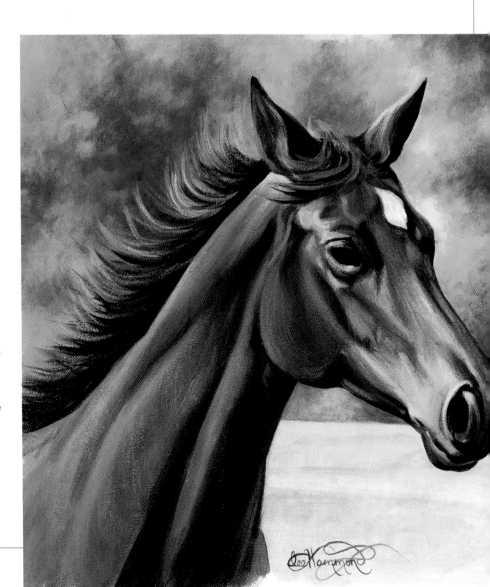

Perfect Portraits

Due to its unique bone structure and soulful eyes, the face of a horse makes a wonderful portrait. They are very graceful animals.

Portrait of a Horse
12" × 11"
(30cm × 28cm)

demonstration
Horse

One of the great things about painting horses is that they give you the opportunity to capture the great outdoors as well. This painting is a good example. The colors of the grass and background help make the light color of the horse stand out.

MATERIALS

paints
Burnt Umber, Cadmium Yellow Medium, Ivory Black, Prussian Blue, Titanium White

brushes
no. 4 filbert, no. 4 flat, no. 3/0 round, no. 2 round

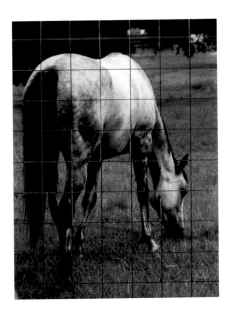

Reference Photo
Use this photo with a grid to begin your painting.

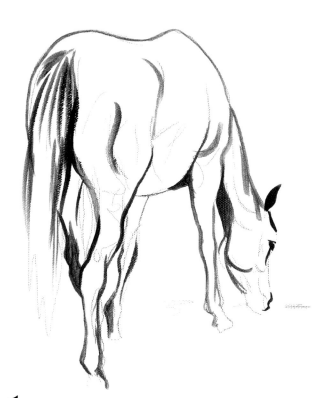

1 Begin With the Outlines
Carefully outline the shapes of the horse with Ivory Black and a no. 2 round.

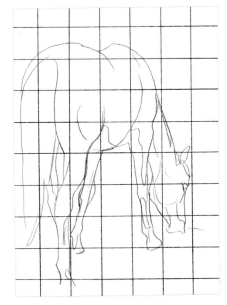

Line Drawing
Use the grid method to create the drawing on your canvas. When your line drawing looks like mine, carefully remove the grid with a kneaded eraser.

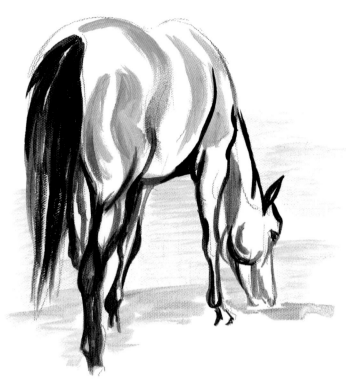

2 Start Filling in the Color

Use the no. 2 round and diluted Ivory Black to wash in the contours of the horse. This step begins to define the form, giving it the look of roundness. Fill in the tail and the darker shadow areas of the horse with a less diluted solution of Ivory Black.

Create a light green by mixing Cadmium Yellow Medium with a hint of Prussian Blue. Dilute the mixture and use a no. 2 round to apply it with horizontal strokes under and around the horse. This color starts to suggest grass.

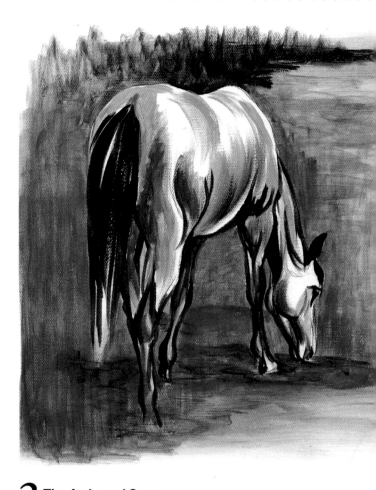

3 The Awkward Stage

Continue building the colors of the horse and background using diluted applications of paint. Use a no. 4 filbert for this entire stage of the painting. Although the sky is not included in the composition, you can see its blue color reflecting off the white areas of the horse. Use Prussian Blue for the sky's reflection.

The brushstrokes will be visible throughout the painting. They curve where the body of the horse is round, and are straight in the background area, where they represent the flat ground, blades of grass and trees.

The shadow underneath the horse gives the painting depth and realism. Create the shadow by applying transparent Ivory Black over the green tones. Use the black to create the row of trees in the background as well.

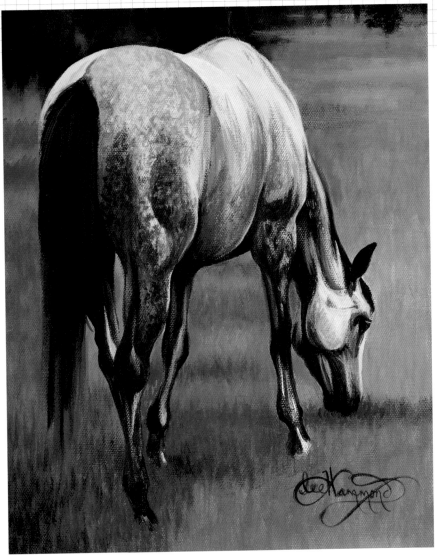

4 Finish

Apply thicker layers of color to finish. With a no. 4 flat, drybrush using a circular motion to give the dappled gray coat a mottled look, alternating light and dark colors. Create the darkest areas with Burnt Umber and Ivory Black, the lighter areas with Titanium White and Prussian Blue. Use pure Titanium White in the brightest areas. The light blue should be used in all highlight areas of the horse. This gives the appearance of the sky's reflections on the horse's coat.

Streak some highlights into the tail using a mixture of Burnt Umber and Ivory Black with a touch of Titanium White. With the no. 3/0 round, make quick, long strokes to replicate the length and texture of the hair.

Use the no. 2 round and quick vertical strokes to create the appearance of grass. Make various shades of green by mixing Prussian Blue with Cadmium Yellow Medium, and Ivory Black with Cadmium Yellow Medium. Look for the shadow areas, and make them darker. Add more Cadmium Yellow Medium and Titanium White to the green mixtures for the highlight area. The grass in the front has more detail. The grass in the background appears smoother, with the highlights streaking across horizontally. Streak Ivory Black and some of the green mixture (Prussian Blue and Cadmium Yellow Medium) into the wet paint to create the illusion of the trees in the background. Make some vertical strokes in the upper right to suggest tree trunks. The lack of detail will make them appear far in the distance.

demonstration
Goat

This little goat was fun to paint. I love his impish face! The coarse hair and the texture are especially interesting. It takes many layers of short strokes to achieve this look, but it is definitely worth the effort.

MATERIALS

paints
Burnt Umber, Cadmium Red Medium, Cadmium Yellow Medium, Ivory Black, Prussian Blue, Titanium White

brushes
no. 4 filbert, no. 2 round

Reference Photo
Use the photo with a grid to achieve the foundation shapes on the canvas paper.

Line Drawing
Remove the grid lines from your canvas when you are happy with your drawing.

1 Begin With the Outlines

Use the no. 2 round and Ivory Black to carefully outline the shapes of the features. Fill in the nose and the pupil. The pupil is elongated like the pupil of a horse.

With a diluted solution of paint, wash in the contours of the face.

2 The Awkward Stage

With diluted Burnt Umber and the no. 2 round, wash in the color of the horns. Add this color to the face and neck. To begin creating texture, apply diluted Ivory Black in curved strokes to the horns.

Add some Cadmium Yellow Medium to the Burnt Umber and apply it to the ear on the left. Use the same color to fill in the iris.

The background plays an important part in this painting. Create a green color by mixing a tiny bit of Prussian Blue into Cadmium Yellow Medium. Use a no. 4 filbert to add this color to the upper-right side of the background. Create a light green by decreasing the amount of blue, then apply it to the left side, above and below the goat. With diluted Ivory Black, apply transparent layers behind the goat on the lower left-side of the background.

3 Finish

Use many layers of thicker paint to complete the painting. Use the no. 2 round to add layer after layer of quick, short strokes. Alternate colors, placing the darker ones first and then layering the white on top. The brushstrokes should follow the hair direction.

Create the orangey color on the neck and face by mixing Burnt Umber with Titanium White, then add a touch of Cadmium Red Medium and a touch of Cadmium Yellow Medium. Apply this mixture with the no. 2 round. Layer white strokes on top to create the texture. On the front of the face, alternate using Ivory Black and Titanium White with the same quick strokes. Add some Burnt Umber to the white and apply it to the hair. Use this color for the edges of the face, neck and chin as well. Use the same colors to complete the small portion of the leg that is visible.

Add the Burnt Umber/Titanium White mixture to the horns. Deepen the color with Ivory Black, and add the dark edges and curved textures. Add more curved lines with the Burnt Umber/Titanium White mixture and a no. 2 round. Using the dry-brush approach, streak highlights down the center of the horn on the left. There is a hint of light blue reflecting off the tips of the horns. Create this color with Prussian Blue and Titanium White.

Finish the background with a thicker application of paint. The background is very vivid, with patches of colors blending together. The upper portion is made with various shades of green (Prussian Blue and Cadmium Yellow Medium) and orange (Cadmium Red Medium and Cadmium Yellow Medium). These colors have some Titanium White mixed in to make them more pastel. Use the no. 4 filbert to apply these colors with horizontal strokes, allowing them to overlap and blend.

Create the foreground the same way, using the no. 4 filbert and many different colors. Use shades of blue, gray, yellow and green. Even use some of the orangey color from the goat's hair. The patterns are not that important, so have fun experimenting and streaking the colors together.

When the background is finished, use the no. 2 round to add the goat's beard with Ivory Black. Streak the hairs downward with quick strokes, allowing the ends to taper.

demonstration
Cow

In art, sometimes the most important element is not what the subject is, but how it looks. This cow is rather ordinary, and the non-artist might see it as boring. However, I immediately saw it as much more than a cow resting in the afternoon sun. It is an amazing collection of artistic patterns and contrasts, and I found it fun to paint. My daughter LeAnne collects cows and everything associated with them. This painting is for her.

Reference Photo
A reference photo is for reference only; you need not become a human copy machine. You can make changes to improve your composition.

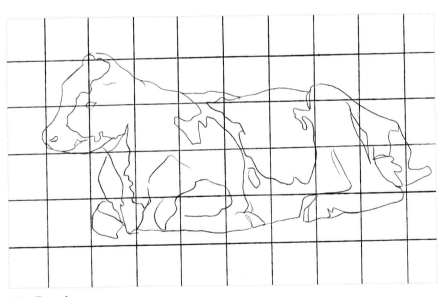

Line Drawing
When your drawing looks like this, carefully erase the grid lines. Notice that the fence in the photo has been eliminated to simplify the painting.

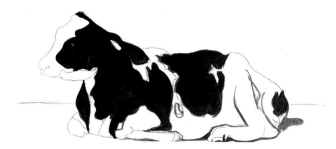

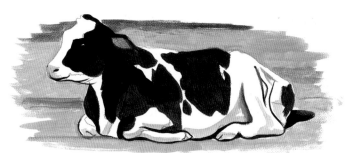

1 Begin With the Outlines

Use the no. 2 round to outline the spots on the cow with Ivory Black. Next, outline the edges of the legs and feet. Do not outline the entire cow since the head, back and rear are white. The color of the background will create those edges instead.

Use the no. 2 round to fill in the spots of the cow with Burnt Umber. Notice the area of shadow on the face and neck, and the shape of the ear being cast on the shoulder. Add these shadows with Ivory Black and the no. 2 round.

2 The Awkward Stage

Make olive green with a tiny amount of Ivory Black and Cadmium Yellow Medium. Apply a diluted solution of this mixture to the background with a no. 4 filbert. Add a small amount of Burnt Umber and paint a streak behind the cow to represent the horizon line. Add another streak farther down to begin the shadow.

Make pink by mixing a touch of Cadmium Red Medium to Titanium White. Use a no. 2 round to apply this color to the nose. Create a warm brown by adding a tiny amount of Burnt Umber to the pink. Apply a diluted solution of this mixture to the ear and shadow edges of the cow.

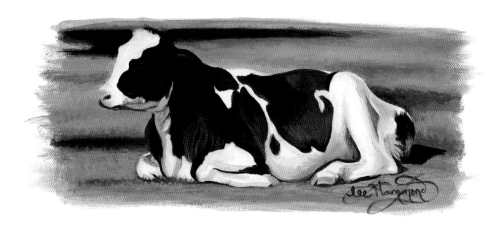

3 Finish

Apply thicker layers of paint to finish. Fill in the white areas of the cow with Titanium White. Reapply the warm brown with the no. 2 round, blending it into the white. With quick strokes and the same brush, apply the hairs coming off the back leg.

Create a light gray with Titanium White and a touch of Ivory Black. Apply the gray to the shadow under the jaw and to the neck. Add the small shadow on the front leg and on the area of the back thigh.

Deepen the color of the spots with another layer of Burnt Umber. Mix a small amount of Titanium White and Cadmium Red Medium into Burnt Umber, and use the no. 2 round to apply highlights to the brown spots. Use this color to contour the bone structure of the face as well.

Use the no. 4 filbert to deepen the background colors with a thicker application of the olive green. Create another green by mixing a tiny bit of Prussian Blue with Cadmium Yellow Medium. Add the warm brown for the lighter tones. Deepen the shadow areas with Ivory Black. Use the scrubbing technique in the foreground to give it a textured appearance.

chapter 8
Painting Small Furry Friends

The animal kingdom offers more variety than I could possibly cover in one book. It was difficult choosing the subjects for these exercises; I wanted to do way more animal paintings than would fit within these pages. As an artist, I want to do it all. As an instructor, I want to show as many techniques as possible.

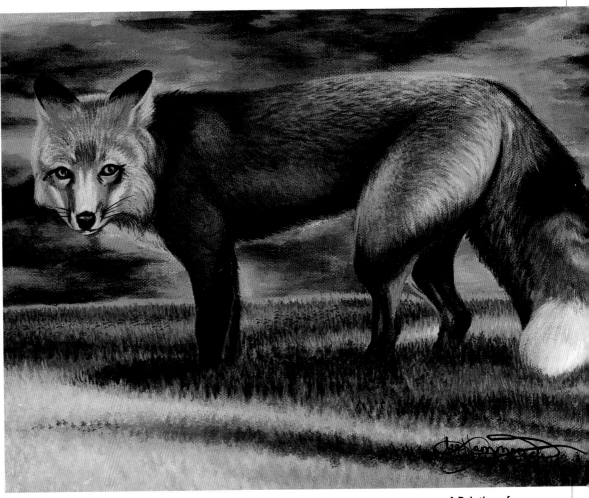

Art Imitates Life

I love the rich autumn colors and the way the sunlight makes the warm colors of the fox's fur glow in this painting. Notice all of the textures of the fur and the grass. I used layers of colors and very short, quick strokes to create these elements of the painting.

The blurred colors of the background create the illusion of distance, imparting a photographic quality to the painting. The detailed fox shown against an out-of-focus background produces a 3-D effect. Our eyes focus on only one level of distance at a time. By using the same type of focus in your work, you create a more realistic effect. Select your references photo carefully, looking for differences in focus. Your artwork will improve as you incorporate these effects.

A Painting of a Red Fox
9" × 12" (23cm × 30cm)

From a photograph by Mel Theisen

demonstration
Squirrel

This photo offers a wide variety of textures. The smooth, speckled fur of the squirrel contrasts with the rough texture of the tree bark and the fluffy fur of the tail.

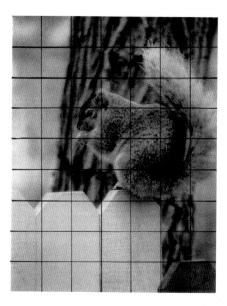

Reference Photo

Use the grid method to capture the shapes of the squirrel on your canvas paper.

Photo by Carol Rondinelli

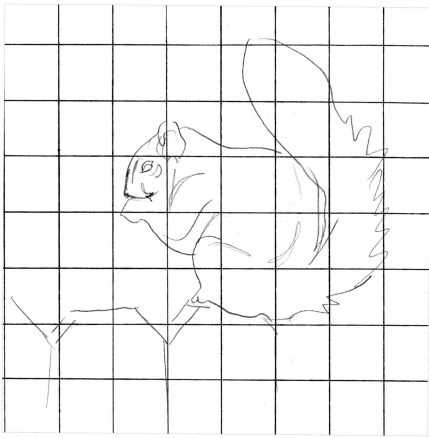

Line Drawing

When you are satisfied with your drawing, erase the grid lines.

1 Begin With the Outlines

Use the no. 2 round to outline the head and other dark areas with Ivory Black. Fill in the eye of the squirrel, leaving a small dot of white for the catchlight. With diluted Burnt Umber and the no. 4 filbert, wash in the color of the tree around and behind the squirrel. Use vertical strokes to begin creating the tree bark.

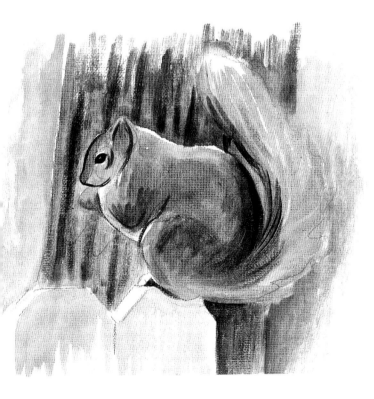

2 The Awkward Stage

Continue adding color to the painting with diluted applications of paint. Apply more Burnt Umber to the tree and to the body of the squirrel.

Use the no. 4 filbert to apply a thicker layer of Burnt Umber in vertical strokes to create the textures of the tree bark. Use this color to start developing the shadow areas of the squirrel.

Create a golden brown by adding a touch of both Cadmium Yellow Medium and Cadmium Red Medium to Burnt Umber. Use the no. 4 filbert to apply this color to the tail, face and front edges of the squirrel.

Create an olive green by mixing a touch of Ivory Black with Cadmium Yellow Medium. Wash a diluted solution into the fence and background with the no. 4 filbert. Add a tiny amount of Prussian Blue to the olive green; apply it to the lower-right side of the background.

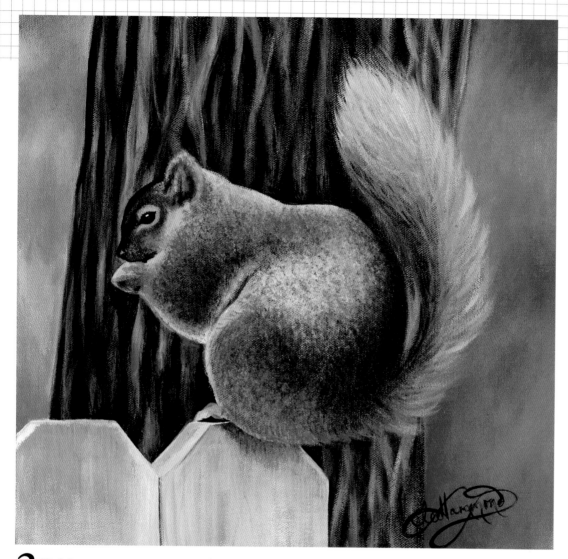

3 Finish

Apply thicker layers of color to finish. Start with the body of the squirrel. Use the dry-brush technique to create the texture of the fur. With a no. 2 flat, layer colors using tight, circular strokes. Start with the darker colors. Scrub Ivory Black over the transparent colors applied in step 2. Drybrush some Burnt Umber on top of the black, using the same circular strokes. Add a thicker layer of the golden brown from step 2. Dab Titanium White highlights on top. Use very dry paint so that it goes on sparingly, without blobs. If blobs do form, scrub the other colors back into it.

Create the long hairs on the tail with the no. 2 round, applying a thicker layer of the golden brown. Use quick, tapered strokes, building the layers to make the tail appear thick. Add quick strokes of Ivory Black to the left side of the tail, and layer in some of the golden brown. Add highlights of Titanium White to the right side and tip of the tail. Repeat this process until the tail looks full and fluffy.

Now, add the tree bark. Alternate light and dark colors with vertical strokes and the no. 4 filbert. Use Burnt Umber and Ivory Black for the dark receding areas. For the protruding highlight area, create a light olive green with Titanium White, a touch of both Cadmium Yellow Medium and Ivory Black, and a small amount of Burnt Umber. Use the dry-brush technique to create texture.

Use the no. 4 filbert to paint the background with various shades of green along with a pinkish color made with Titanium White, Cadmium Red Medium and a touch of Burnt Umber. Use swirling brushstrokes to give the background an out-of-focus, mottled look.

Now, create the fence. Apply shades of yellow and ivory, made with Titanium White and a touch of Cadmium Yellow Medium, with the no. 4 filbert, using vertical strokes. Add a tiny amount of Ivory Black to the ivory mixture to create subtly darker color variations. Add this mixture on top with the same vertical strokes. Apply Titanium White along the edges of the fence for reflected light.

Reflect a small amount of the golden brown below the squirrel. Use Burnt Umber and a no. 2 round to create a small cast shadow directly below the squirrel.

demonstration
Rabbit

Like the squirrel, this little bunny is very textured. Each hair is distinct, and its length shows clearly. I created each tiny hair with a fine brush and quick, tapered strokes. The rabbit fur is very different from the short, blended fur of the squirrel. You will use drybrushing to create this texture. This project will require more patience. Tiny strokes and more layers take more time.

MATERIALS

paints
Alizarin Crimson, Burnt Umber, Cadmium Red Medium, Cadmium Yellow Medium, Ivory Black, Prussian Blue, Titanium White

brushes
no. 4 filbert, no. 3/0 round, no. 2 round

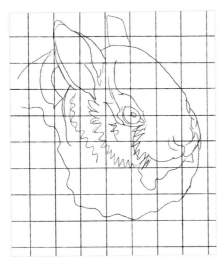

Reference Photo
Use the grid lines on this photo to obtain an accurate drawing.

Photo by Mel Theisen

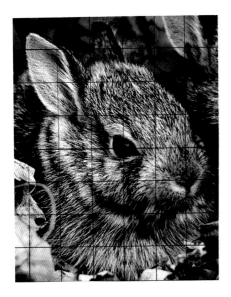

Line Drawing
When your line drawing looks like mine, carefully remove the grid with a kneaded eraser. This is the same drawing that we did in the exercise on page 41.

1 Begin With the Outlines

With the no. 2 round and Ivory Black, carefully outline the shapes of the rabbit. Fill in the eye, leaving a small dot of white for the catchlight.

2 The Awkward Stage

With the no. 4 filbert, block in the colors of the painting with a diluted application of paint. Use Cadmium Yellow Medium for the head and face. With Burnt Umber, wash in the nose area, the right ear, the neck and the body.

Combine a bit of Alizarin Crimson with Burnt Umber, then add this color to the inside of the ear on the left. Create a green with Cadmium Yellow Medium and Prussian Blue, and apply it to the background.

Switch to a no. 3/0 round and create the facial hairs with tiny, quick strokes of Ivory Black. Follow the direction of the hair growth.

3 Finish

Add a tiny bit of Prussian Blue and Titanium White to the catchlight of the eye. Create an orangey color by mixing Cadmium Red Medium with Cadmium Yellow Medium. Apply a small edge of this color around the eye with the no. 3/0 round.

With the same brush and Ivory Black, develop the dark patterns of the fur. These patterns look like stripes around the neck. Use tiny strokes to replicate the fur.

Apply the orangey color to the area around the nose and mouth and to the ear on the right with the no. 2 round. Make quick strokes. Layer some black strokes on top to make these areas look furry.

Apply a cream color made with Titanium White and a touch of Cadmium Yellow Medium to the light areas of the rabbit with a no. 2 round. Overlap this color in the dark areas and over the orangey color of the nose and chest.

To make the fur look realistic, it is important to overlap the three colors in many layers. Study the finished painting closely; notice how many layers I applied to build up the thickness of the fur. The black, cream and orange overlap everywhere. Sometimes the dark colors overlap the light colors and vice versa.

Complete the painting by deepening the colors of the background. Use the no. 4 filbert and circular, swirling strokes to blend the colors. Apply a thicker layer of the green used in step 2. Deepen it in the upper-left corner with more Prussian Blue and a touch of Ivory Black. Use this color along the right side of the bunny to create a hint of shadow.

demonstration
Woodchuck

The process for painting this little woodchuck is very similar to the method we used to create the bunny in the previous project. We will use small, quick strokes to create the texture of the fur.

MATERIALS

paints
Burnt Umber, Cadmium Red Medium, Cadmium Yellow Medium, Ivory Black, Prussian Blue, Titanium White

brushes
no. 4 filbert, no. 2 round

Reference Photo
Use the grid method to capture the wood-chuck on your canvas paper.

Photo by Mel Theisen

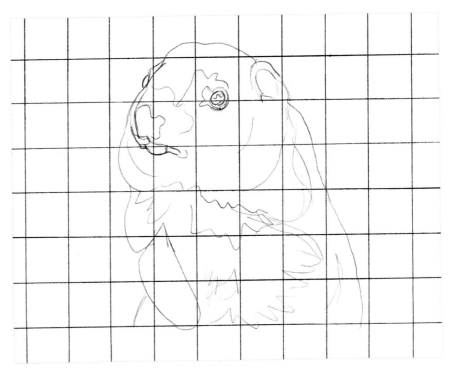

Line Drawing
When you are sure of the accuracy of your drawing, remove the grid lines with a kneaded eraser.

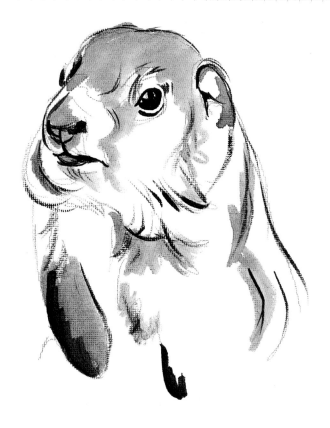

1 Begin With the Outlines

Use the no. 2 round and Ivory Black to carefully fill in the eye. Leave small dots of white for the catchlights. Outline the other features of the woodchuck. Wash in the dark areas of the head, nose, mouth and front paw with diluted Ivory Black.

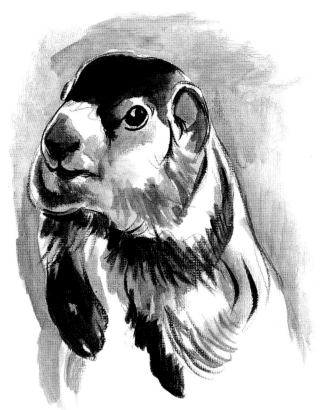

2 The Awkward Stage

Using a thicker application of paint and the no. 2 round, deepen all of the black areas. Start to create the appearance of fur with quick strokes under the chin and on the side.

With a diluted solution of Burnt Umber, wash some color into the front of the face and chest area and on the side.

Create a shade of green by adding a tiny amount of Prussian Blue to Cadmium Yellow Medium. Add a diluted solution of this color to the background with the no. 4 filbert. Add some of the diluted Burnt Umber to the background as well.

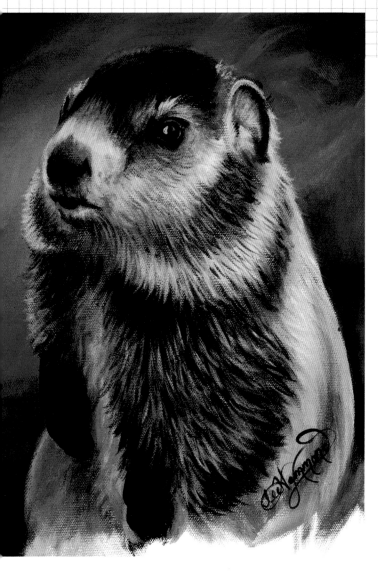

3 Finish

Apply thicker layers of color to finish. Make a lighter color with Titanium White, a small amount of Burnt Umber and a touch of Cadmium Red Medium. In the neck area, use the no. 2 round to overlap the previously applied black with quick, short strokes. Continue adding to the hair layers. Layer quick brushstrokes, working with the dark colors first. Start with Ivory Black, following the color patterns of the fur.

Next, add a warm brown under the chin and into the chest and side. Create this color with Titanium White, small amounts of Burnt Umber and Cadmium Red Medium and a touch of Cadmium Yellow Medium. Use the same quick strokes and the no. 2 round.

Before you finish the woodchuck, it is important to finish the background colors. If you finish the background first, you will be able to overlap the fur into it later. Apply a thicker layer of the same green tones used in step 2 to the background with circular, swirling strokes. Deepen the green tones by adding more Prussian Blue and Ivory Black. Swirl it into the corners of the painting, allowing it to blend with the other green colors. Add earth tones to the background by adding the same warm brown used on the woodchuck. Blend it into the other colors, using the swirling strokes, to create an out-of-focus background. Then, bring the light color of the fur out into the background.

Use reflected color to create a more realistic effect. Although the sky is not included in the composition, you can see its blue color reflecting on the top of the head. Add a tiny amount of Prussian Blue to Titanium White, and then gray it down with a bit of Ivory Black. Use the no. 2 round to apply this color to the head, between the eyes and inside the ear with small, quick strokes. You can also see the green of the background reflecting on the sides of the body. Add more Titanium White to the background color and apply it to the woodchuck with a no. 4 filbert.

Note

You can see how the same process can be used for many different types of animals. Look through pictures in magazines and books to find a variety of animals and have fun painting. Use the grid method to capture their shapes, and practice the painting techniques you have learned so far. You'll be amazed that, through practice, you can create perfectly real looking critters.

chapter 9
Painting Exotic Animals
and Reptiles

The jungles offer a multitude of amazing animals. Their unique colors and patterns inspire beautiful artwork and provide an opportunity to hone your artistic skills.

The reptilian subjects at the end of this chapter may not be appealing to everyone, but wonderful paintings can be made of even the most unusual creatures. These examples may not have cute fur or colorful feathers, but they do have very interesting textural qualities.

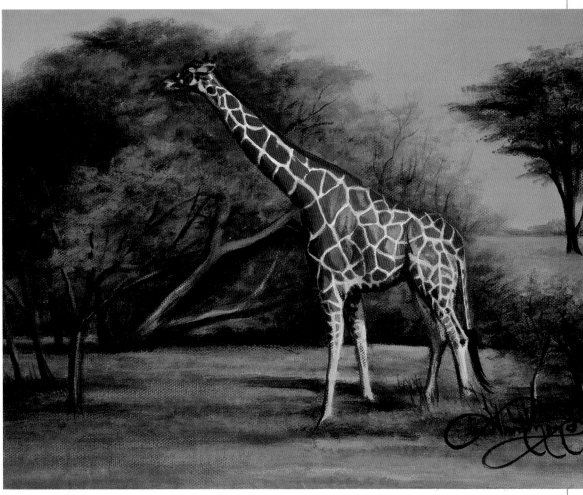

Pay Attention to the Surroundings

I love the patterns of the giraffe's coat and the wonderfully unique body shape. The entire scene comes together to make a great painting. By combining the semi-out-of-focus background with the clear, distinct patterns of the giraffe, the painting gains an almost 3-D effect. Often, the background and surroundings are just as important as the painting's subject.

A Painting of a Giraffe

9" × 12"
(23cm × 30cm)

demonstration
Tiger Face

I love patterns. When selecting reference photos, I am always attracted to the pictures with the most extremes, in both color and contrast. Tigers exhibit both of these elements beautifully. This photo will give you practice creating an amazingly intense painting.

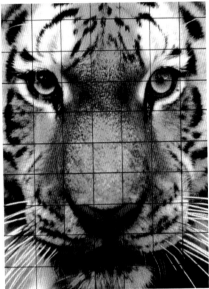

Reference Photo
Using the grid method, copy the abstract patterns of the tiger's face onto your canvas paper.

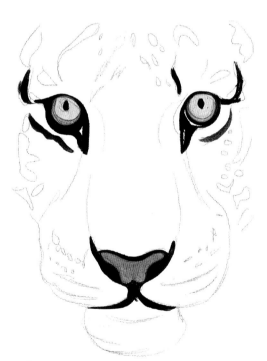

Line Drawing
When you are sure that your drawing is accurate, erase the grid lines. This is the same drawing that we drew in the exercise on page 38.

1 Begin With the Outlines
The eyes are the most striking feature of this painting. Outline the eyes with Ivory Black and the no. 2 round. Fill in the pupils.

Fill in the color of the eyes with a transparent application of a light olive green made with Cadmium Yellow Medium and a tiny bit of Ivory Black. Outline the irises with a thin line of Cadmium Red Medium.

Outline the nose with Ivory Black. Then fill the nose in with a mixture of Titanium White and a dab of Cadmium Red Medium.

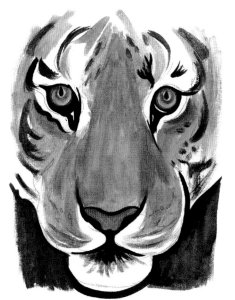

2 The Awkward Stage

Continue building the color and intensity of the eyes. There is a distinct light edge around the pupil. Add a little more Ivory Black to the olive green mixture, and apply it with the no. 2 round around the pupil, allowing the light ring to remain visible.

Make a diluted orangey color from Cadmium Red Medium and Cadmium Yellow Medium. Use the no. 4 filbert to apply this color to the face as shown. Be sure to leave the white areas around the eyes, the nose, the mouth and the sides of the face exposed.

Begin filling in the background with diluted Ivory Black. This wash helps define the edges of the face.

3 Finish

Apply thicker layers of color and add the small details to finish. With a no. 3/0 round and Titanium White, add the catchlights to the irises. Notice how glassy this makes the eyes appear.

Continue building the fur with a thicker application of the orange used in step 2. Create a deeper version of that color by adding some Alizarin Crimson. With the no. 2 round, add this to the sides of the face and to the area next to and above the nose. Also add this color to the tip of the nose. Do not take this color to the edges; allow a light edge of reflected light to show around the nostrils.

Mix a light version of the orange by adding a dab of Titanium White. Apply this to the outside edges of the face, the edge above the nose and around the whisker area.

Add a small amount of Burnt Umber to the light orange, then drybrush this mixture on the front of the face above the nose to add texture. To make the tiger look furry, you need to create the appearance of small hairs. Use the no. 2 round to fill in the white areas of the tiger's face with Titanium White. Use quick strokes to overlap the orange colors that have already been applied. Don't add the whiskers yet.

Use the no. 4 filbert to fill in the background with a thick layer of Ivory Black. Use the no. 2 round to add the dots where the whiskers originate, including the chin. Add a few black whiskers with quick strokes of the no. 3/0 round. Finally, add the white whiskers and the hairs on the chin. The whiskers should overlap the background.

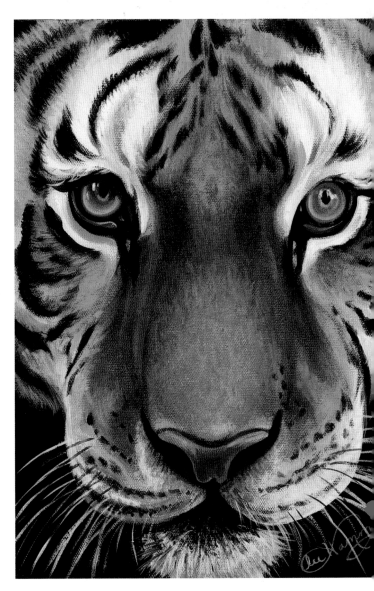

Elephant

Some animals are more about shape than color. Few animals have a shape as recognizable as that of an elephant. Lacking the fur that most other species have, this guy is all about painting texture. The wrinkles and rough skin make it a fun challenge. I think you will enjoy it too.

MATERIALS

paints
Burnt Umber, Cadmium Yellow Medium, Ivory Black, Prussian Blue, Titanium White

brushes
no. 4 filbert, no. 4 flat, no. 3/0 round, no. 2 round

Reference Photo
Remember to draw one box at a time. Turn the photo and your drawing upside down for more accuracy as you work.

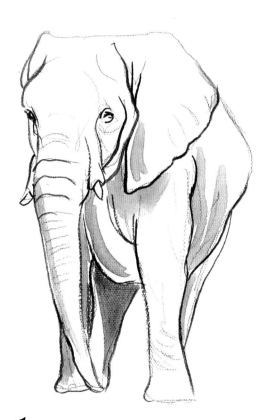

1 Begin With the Outlines
With a no. 2 round and Ivory Black, carefully outline the shapes of the elephant. Wash in the dark areas of shadow with diluted Ivory Black.

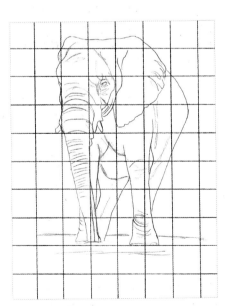

Line Drawing
When your drawing looks like this, you can remove your grid lines with the eraser. Be careful. Do not accidentally erase any of the details in the process.

2 The Awkward Stage

Create a medium gray with Ivory Black and Titanium White. Apply the mixture to the elephant with the no. 2 round, building the tones. Allow the light areas to remain white. Mix more Ivory Black into the gray to make a dark gray, and apply it to the darker areas of the elephant's belly and legs.

Mix Cadmium Yellow Medium, Prussian Blue and Titanium White to create a green for the background. Next, make an olive green by mixing Cadmium Yellow Medium with Ivory Black and a touch of Titanium White. Apply both these tones with the no. 4 filbert, using a scrubbing, circular motion. For the deep areas behind the elephant, use more Ivory Black. Even at this stage, the forms should give the appearance of foliage in the distance.

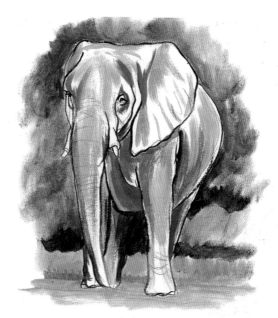

3 Finish

Apply thicker layers of color to finish. Continue to use shades of gray to build the tones of the elephant's skin with the no. 2 round. For more color, add a touch of Burnt Umber to the gray. The dark colors recede, and the light colors come forward. This technique helps create the contours of the bone structure and the indentations of the ear. Pay attention to the direction of the brushstrokes. Their curves help create the round form of the elephant. You can see them particularly in the legs and belly.

The trunk is extremely textured. Use a no. 3/0 round and dark gray to create the dark lines that curve around it. Apply Titanium White between the dark lines to give the illusion of ridges. Look at the shadow running down the left side of the trunk. Notice the edge of reflected light. Create the shadow with dark gray. Remember, follow the direction of the ridge. Allow the light to remain on the edge.

Continue with the green tones of the background, using the no. 4 flat to drybrush the paint in small, circular strokes. The foliage is built from dark to light, using the various shades of green used in step 2. Once the forms of the trees and brush are completed, apply highlights with Titanium White. Create the small area of grass directly behind the elephant with the same green colors and brush, but use straight, vertical strokes instead.

Make a very light grayish green with Titanium White, a touch of Ivory Black and a tiny bit of the green from the background. Use the no. 4 filbert to apply this color with horizontal strokes underneath the elephant. Add more deeper green tones to create the streaking shadows.

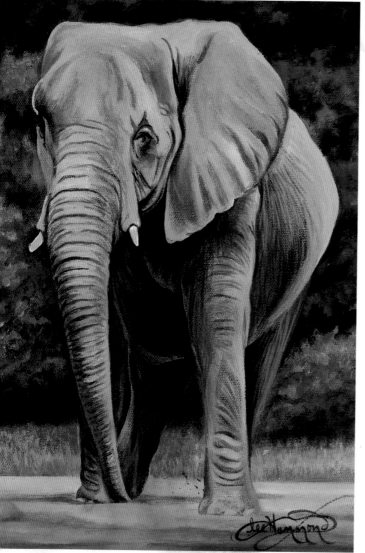

101

demonstration
Lion

The pose of this lion reminds me of the Sphinx. It has an air of command and dignity. The rich colors of the lion contrast strongly against the background colors. The red tones of the fur act as a complement to the green tones behind it.

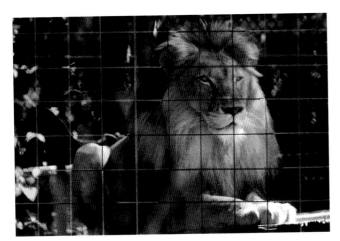

Reference Photo
Use the grid method to capture the "King of Beasts" on your canvas paper.

Photo by Carol Rondinelli

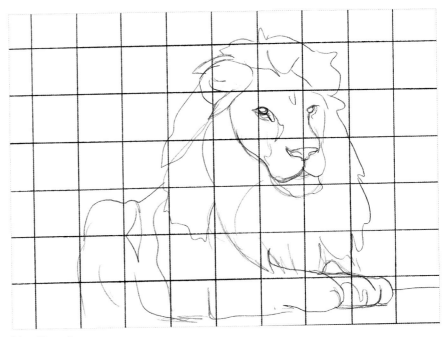

Line Drawing
When you are satisfied with the accuracy of your drawing, erase the grid lines with a kneaded eraser.

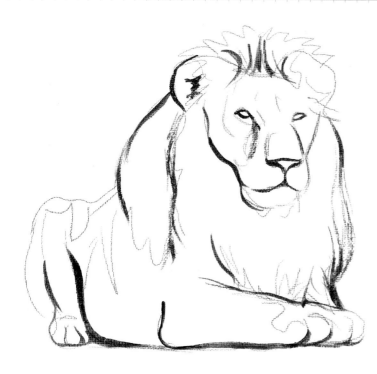

1 Begin With the Outlines

Use the no. 2 round to outline the shapes of the lion with Ivory Black. Do not outline the top of the head or the lower backside. These edges are light, so the background will create those edges instead.

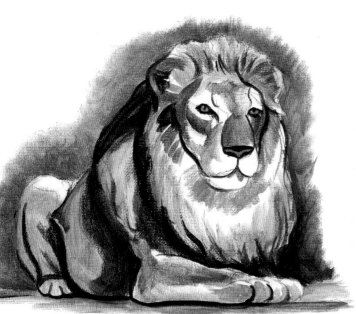

2 The Awkward Stage

Use the no. 2 round and diluted paint to block in the colors. Apply a transparent layer of Burnt Umber to the sides of the face and to the nose and the area around it. Add some of this color to the top of the front leg.

Apply a thicker layer of Burnt Umber to the shadowed areas on the side and under the mane as well as on the top of the back. Add some Cadmium Yellow Medium to Burnt Umber to create a golden brown. Apply this color to the areas of the ear and mane, and fill in the eyes.

Add Cadmium Red Medium to Burnt Umber to make a rust color. Use this on the nose and under the chin, then apply it to the lower edge of the front leg and paw, and fill in the side of the belly and the rear leg and thigh.

Make a green with Cadmium Yellow Medium and Prussian Blue, and fill in the background. The bottom is a deeper color, with more Prussian Blue

For the area under the lion, mix a gray from Ivory Black and Titanium White with just a touch of the green from the background to make it look more colorful.

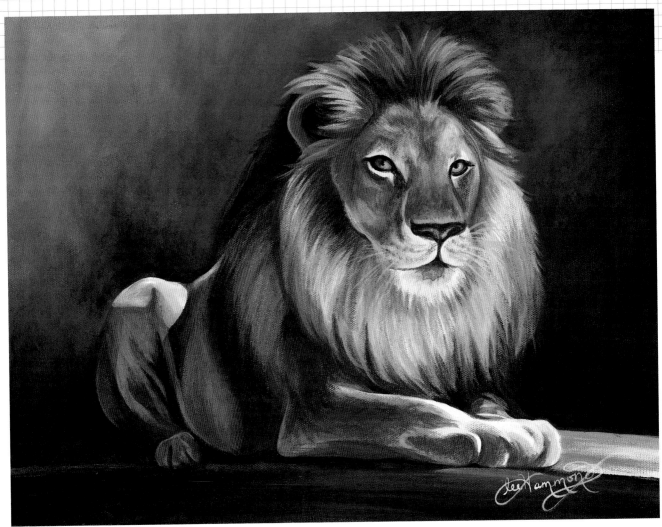

3 Finish

Apply thicker layers of color to finish. This stage is all about the brushstrokes. Create the mane with long strokes that follow the direction of the fur. Layer the colors from dark to light. Use the Burnt Umber first, then the rust, and then the golden brown. To deepen and richen the red tones of the fur, add some Alizarin Crimson to the rust. Use Titanium White for the highlights. These colors combined with the brushstrokes make the mane look thick.

Create the rest of the body with layers of the same colors. Study the finished example to see how I used the three colors to create the lights and darks of the fur. The strong light source provides a lot of contrast. All of the bright highlight areas are Titanium White. Use Titanium White and quick strokes to paint the whiskers.

Use the no. 4 filbert to apply thicker applications of green to the background in swirling brushstrokes. Vary the colors, using the light shades on the left side and the dark shades on the right and toward the bottom.

Create the surface that the lion is lying on with shades of gray. It is quite dark underneath the lion. Combine Burnt Umber, Ivory Black and Titanium White for this color. Use the no. 4 filbert. Then add a touch of Titanium White and a touch of the green from the background to the gray, and streak it into this area so that it won't look flat and boring. Streak some of the golden brown along the left edge of the ground to separate this surface from the background.

The top portion of the surface, which is to the right of the lion's front paws, is much lighter due to the light source. Add a lot of Titanium White to the gray mixture, and apply it here. Streak some medium gray into it. Add a small touch of Cadmium Red Medium to the light gray, and apply it to the top edge of the surface.

Turtle

Turtles are my daughter Shelly's favorite critters. I am always collecting turtle mementos for her, and I always jump at the chance to take a good turtle photo. I created this painting for her.

MATERIALS

paints
Burnt Umber, Cadmium Red Medium, Cadmium Yellow Medium, Ivory Black, Prussian Blue, Titanium White

brushes
no. 4 filbert, no. 3/0 round, no. 2 round

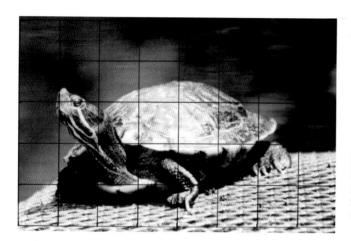

Reference Photo
Use the grid method to draw the turtle on your canvas paper.

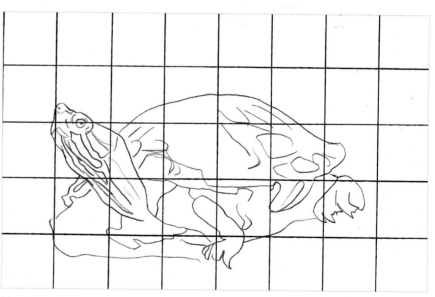

Line Drawing
When your drawing looks like mine, erase the grid lines.

1 Begin With the Outlines

Use the no. 2 round to outline the shapes of the turtle with Ivory Black. Do not outline the upper edge of the shell, because it will need a light edge. Use the black to fill in the shadow under the turtle. Fill in the front left leg. Create the small, delicate lines on the neck with a no. 3/0 round.

2 The Awkward Stage

Use the no. 2 round and diluted paint to block in the colors. Use Burnt Umber for the head, neck area and chest as well as the lower portion of the shell.

Create a golden brown by mixing Burnt Umber with Cadmium Yellow Medium. Apply this mixture to the underside of the shell.

With diluted Ivory Black, wash in the color on the top of the shell and the front right leg. Switch to the no. 4 filbert and wash in the color below the turtle. In the original photo, which was taken at a local zoo, the turtle is resting on a rock draped with a mesh cover. To create a more natural look, I decided to eliminate the mesh.

Make a green color with Cadmium Yellow Medium and a touch of Prussian Blue. Wash this color into the background, behind the turtle. Switch to the no. 2 round, and add more Cadmium Yellow Medium to make a chartreuse. Apply a diluted solution of this color to the stripes of the neck.

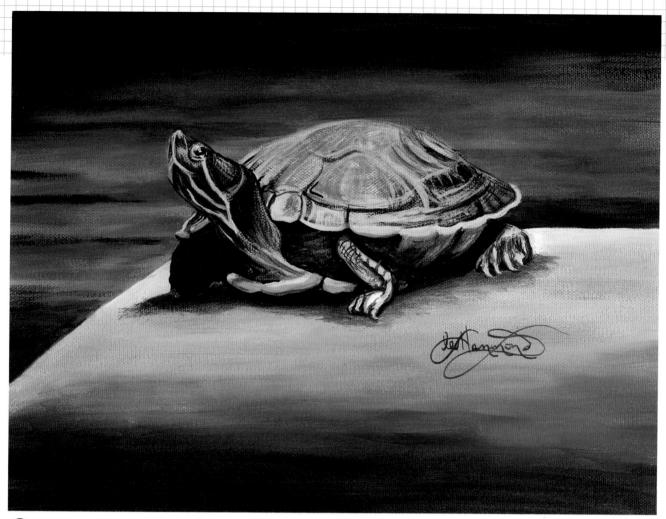

3 Finish

Starting with the turtle, strengthen all of the colors used in step 2. Create the texture of the turtle shell with the dry-brush technique. But, first, intensify the patterns on the back end of the shell with Ivory Black and the no. 2 round. Then, create a light shade of blue-gray with Titanium White, a touch of Ivory Black and a very small touch of Prussian Blue. Add this to the top of the shell with a no. 2 round, painting in the geometric patterns. Allow the colors from step 2 to show through. Drybrush Titanium White on top for texture and highlights.

Strengthen the brown colors of the head, neck and body with a thicker application of Burnt Umber. Use small strokes of Ivory Black and Titanium White to create the tiny lines and wrinkles of the skin, using the no. 3/0 round. Look closely at the front left leg to see the way these tiny lines add character and detail. The skin and legs are covered with these details and textures. Use these Ivory Black and Titanium White lines to create the right leg and hind foot. Add a touch of Burnt Umber to the hind foot, above the claws.

Intensify the colors on the edge of the shell with Cadmium Yellow Medium and an orange made with Cadmium Red Medium and Cadmium Yellow Medium. Enhance the light colors in the neck area, using the chartreuse from step 2. Use the no. 3/0 round and this color for the tiny streaks of color on the underneath section of the shell.

Use the no. 4 filbert and thicker layers of paint to finish the background. Streak the green colors with horizontal brushstrokes, varying the colors. Add some Ivory Black to the green tones for the upper edge of the painting to give the illusion of distance. Apply this dark color to the area behind the edge of the rock. Streak some red tones into the background using a mixture of Cadmium Red Medium and Titanium White.

Use a no. 2 round to complete the rock with shades of gray, becoming darker towards the bottom. Create the cast shadow under the turtle with the blue-gray used on the shell. Use the dry-brush technique to streak the same red tones of the background across the surface of the rock.

Snake

This is a fabulous photo of a snake. The illusion of distance combined with the shapes and patterns of the snake make a very interesting painting. The face of the snake is definitely the focal point, with the rest of the body fading into the background. These elements contribute to the three-dimensionality of the painting.

MATERIALS

paints
Burnt Umber, Cadmium Yellow Medium, Ivory Black, Prussian Blue, Titanium White

brushes
no. 4 filbert, no. 3/0 round, no. 2 round

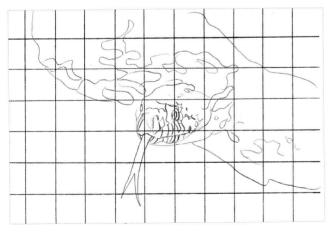

Reference Photo
Use the grid method to draw the snake on your canvas paper.

Photograph by Mel Theisen

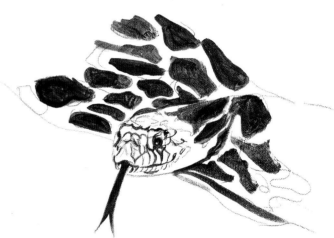

1 Begin With the Outlines
This painting is made up of geometric shapes. Use the no. 2 round to fill in the shapes on the body of the snake with Ivory Black. Fill in the tongue and the eye, allowing a white dot to remain for the catchlight. Carefully add some of the small lines on the front of the face and around the mouth with a no. 3/0 round.

Line Drawing
When you have the shapes drawn accurately, remove the grid lines with your eraser, leaving the image behind.

2 The Awkward Stage

Add a touch of Ivory Black to Titanium White to create a light gray. With the no. 2 round, apply this color between the black lines previously added to the face of the snake.

Add a touch more Ivory Black and a touch of Cadmium Yellow Medium to the light gray to create a light olive green. Apply this mixture between the black geometric patterns of the snake's body.

Create a blue-gray by mixing Titanium White, Ivory Black and a tiny bit of Prussian Blue. With the no. 2 round, apply this color over the olive green, using the dry-brush technique. Allow the blue-gray to overlap some of the black. Since everything but the face will be out of focus, you need the colors to blend without hard edges.

Add the blue-gray along the left edge of the head. Add a touch of Titanium White to this color and fill in the area between the black patterns on the right side of the head.

Use a no. 4 filbert to apply diluted blue-gray to the area of color under the snake with swirling strokes.

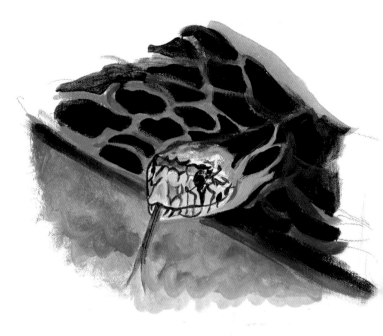

3 Finish

Apply thicker layers of color to finish. Start with the face, using a no. 3/0 round to reapply all of the small black lines, making sure all of the features have crisp, clean edges. Reapply Ivory Black to the tongue.

Mix a light brown with Titanium White and a touch of Burnt Umber. With the no. 3/0 round, add the small areas of color over the light gray applied previously. Add some small blue-gray details to the top of the head and the face. Use the no. 3/0 round to make these small dots.

Move to the body of the snake. Add more blue-gray to the light color. Allow it to blend into the black, softening the edges. Continue this process until the body looks out of focus. Mix some more Prussian Blue into the blue-gray and apply it to the neck, directly behind the head.

With the no. 4 filbert, apply light gray to the top of the painting behind the snake, using a swirling stroke. With Titanium White, add a light edge where the background color meets the back of the snake. Allow the color to overlap the edge. Create a light blue with Titanium White and a tiny touch of Prussian Blue. Swirl this into the upper corner, making it blend with the other color layers. Add the same colors in the foreground over the color already applied. Swirl the colors together, creating a mottled look. Swirl some Ivory Black into the mix to create the appearance of a shadow.

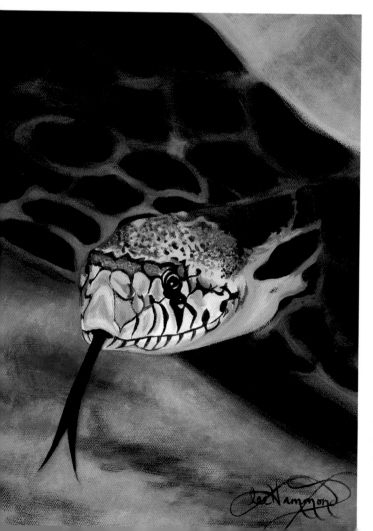

demonstration

Iguana

This is a little friend I met in Cozumel, Mexico. I used this iguana as a subject before in my book *Drawing Realistic Pets From Photographs*. As nice as that drawing was, I knew the day would come when I would have to paint him in full color.

Unlike the green iguanas I have seen in pet shops all my life, this one really caught my attention with its beautiful orange and black coloration. And, unlike the ones I have had as pets, this one was a good four feet long! Not only was the color an artistic challenge, the texture was fun to tackle.

MATERIALS

paints
Alizarin Crimson, Cadmium Red Medium, Cadmium Yellow Medium, Ivory Black, Prussian Blue, Titanium White

brushes
no. 4 filbert, no. 3/0 round, no. 2 round

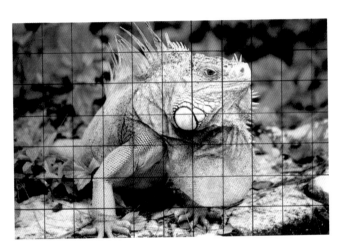

Reference Photo
Use the grid method to capture the Mexican iguana from Cozumel on your canvas paper.

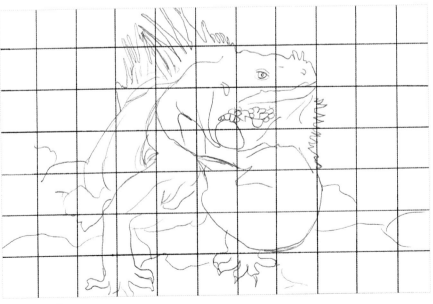

Line Drawing
When you are sure that your drawing is accurate, erase the grid lines with your kneaded eraser.

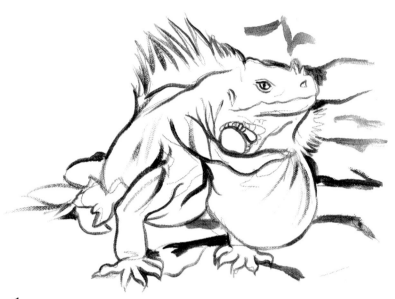

1 Begin With the Outlines

Use the no. 2 round to carefully outline the shapes of the iguana with Ivory Black. Apply some lines to the background as well.

2 The Awkward Stage

Block in the colors of the iguana with diluted paint. Create orange tones by mixing Cadmium Red Medium with Cadmium Yellow Medium. The area of the spikes and the front of the neck protrusion have more red. The area along the neck and chest are more yellow in color. Use the no. 2 round. Fill in the color of the eye with the redder mixture. Mix a gray color with Titanium White and Ivory Black. Add this color to the back of the head, the front of the face and the area under the chin. Then add this color to the ground area below the iguana.

Mix some green colors with Cadmium Yellow Medium and Prussian Blue. Some areas appear bluer, and some are more yellow. Form the shapes of foliage in the background with these colors and the no. 2 round.

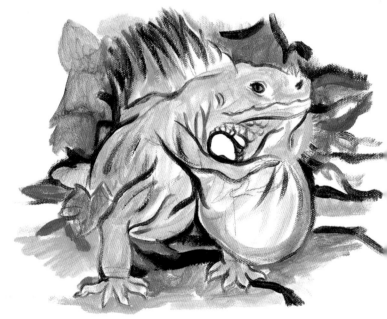

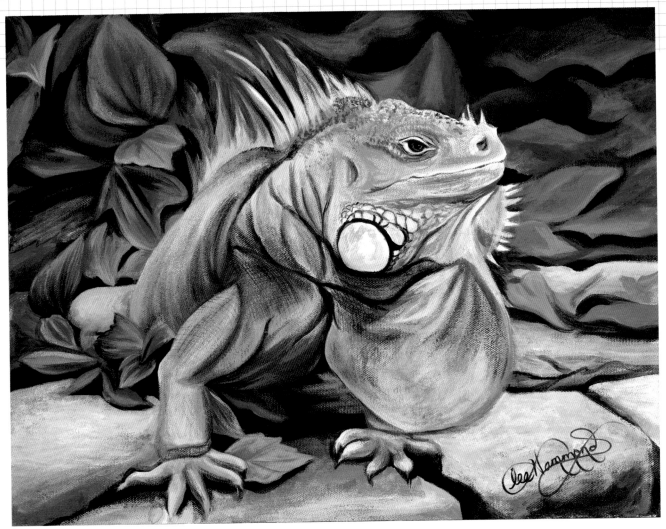

3 Finish

Apply thicker layers of color to finish. This is one of the most involved paintings yet. It requires many layers of color, all of the brushstroke techniques we have covered so far plus a few new ones.

Start with the iguana. Use the dry-brush technique to add more of the orange colors, allowing the texture of the canvas to come through. Add more of the gray using the same approach. Allow the colors to overlap. Add a bit of Ivory Black to the orange color with a greater percentage of yellow and apply this to the lower chest area.

With the no. 3/0 round, crisscross tiny lines for texture. This technique is called *crosshatching*. You can see it in the leg and shoulder on the left and under the neck. Apply many small dots on top of the head. This technique is called *stippling*.

Use the no. 2 round and Titanium White to add the highlights and details of the face and spikes. Drybrush some Titanium White on the body to make it appear more textured. Fill in the circular protrusion on the side of the face with Titanium White. Create a pearlescent look by swirling color onto it when it is dry. First add a small amount of diluted Prussian Blue, then a small amount of diluted Alizarin Crimson.

Build up the foliage and leaves with various shades of green, first applying Ivory Black behind them. Edge the leaves with lighter colors to make them stand out.

Create the stones beneath the iguana with varying shades of gray, layering the tones from dark to light. If you look closely, you can see some of the orange of the iguana reflected on the stones. Drybrush orange into the stones with the no. 4 filbert, then Titanium White for the top layer to make the stones look reflective. Drybrushing adds texture to the stones.

chapter 10
Painting Birds

Birds are popular subjects for paintings, and it is easy to see why. They offer a variety of colors and textures not ordinarily found in the rest of the animal kingdom. The natural surroundings of avian environments can provide wonderful artistic opportunities as well.

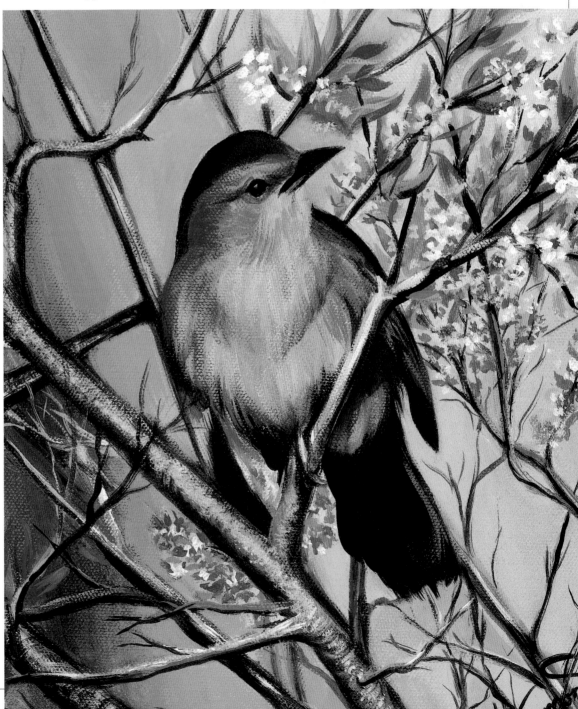

Environment Adds Beauty

This piece is an example of how the natural surroundings offer an additional element of beauty.

A Bird in the Tree
12" × 9"
(30cm × 23cm)

From a photograph by Mel Theisen

demonstration
Robin

This project demonstrates how a nontraditional photo can be transformed into a beautiful painting. This photo is a wonderful example of extreme contrasts that can produce dramatic results in your painting. The little robin is barely discernible in the darkness of the trees, yet it captures the eye. The colors contrast strongly against the jet black background.

MATERIALS

paints
Alizarin Crimson, Burnt Umber, Cadmium Red Medium, Cadmium Yellow Medium, Ivory Black, Prussian Blue, Titanium White

brushes
no. 4 filbert, no. 3/0 round, no. 2 round

Reference Photo
Use the grid method to draw the robin on your canvas paper.

Photograph by Mel Theisen

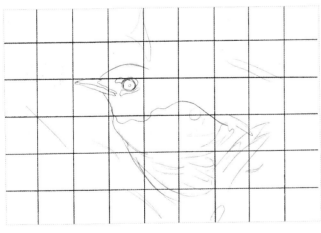

Line Drawing
Your line drawing may look abstract due to the contrasts, but don't worry. It will become more realistic during the painting process. This step will merely get the shapes properly placed on your paper.

1 Begin With the Outlines
Use the no. 2 round to outline the edge of the body and the wing area with Ivory Black. Fill in the eye, leaving a small dot of white for the catchlight. Begin filling in the head of the robin, and the background area behind the beak.

114

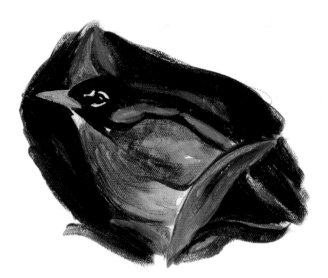

2 The Awkward Stage

Use the no. 4 filbert and Ivory Black to fill in the background. Switch to the no. 2 round and fill in the red breast of the robin with diluted Cadmium Red Medium. Fill in the beak with diluted Cadmium Yellow Medium.

Make a light violet with Titanium White, a dab of Alizarin Crimson and a touch of Prussian Blue. Use the no. 2 round to add this color to the wing area.

Create a green with Cadmium Yellow Medium and a tiny amount of Prussian Blue. Apply this color with the no. 2 round to create the appearance of leaves.

3 Finish

Apply thicker layers of paint to finish. Add pure Cadmium Red Medium to the breast area using the no. 4 filbert. Allow your brushstrokes to follow the direction of the feathers. Then add a touch of Alizarin Crimson to the Cadmium Red Medium to make a deep red and apply it over the initial red layer.

With Ivory Black, streak shadows into the feathers on the lower breast area following the growth direction and using the dry-brush technique. Add highlights of Titanium White to the feathers the same way. Drybrushing keeps the paint from becoming too heavy and filled in.

With the no. 3/0 round, add Cadmium Red Medium to the upper beak. Mix some Cadmium Yellow Medium with a touch of Burnt Umber, then fill in the lower beak. Add more Burnt Umber and outline the edge between the upper and lower beaks. With the same brush and Titanium White, add an edge of reflected light along the edge of the upper beak, and a spot of highlight on the side of the lower beak.

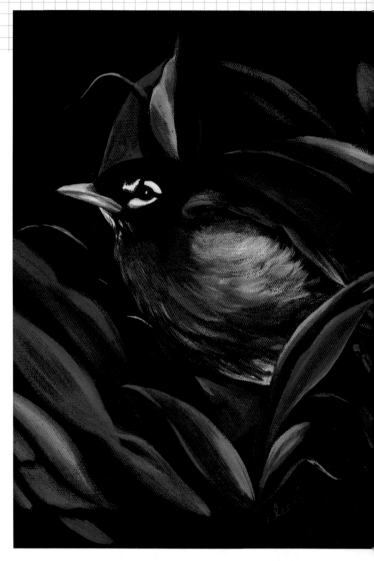

Fill in the head and back of the robin with a thick layer of Ivory Black. Next, fill in the white shapes around the eye and the white spot under the beak with Titanium White and a no. 2 round.

Reapply the light violet from step 2 on the edge of the wing, being sure to get good coverage. Add a bit more Alizarin Crimson to the mix and highlight the edges of this area where it meets the black. If you look closely, you can see where I also applied a hint of these colors to represent the tail behind the leaves.

Fill in the black of the background so that it is even and opaque. The canvas must be completely covered. With various shades of green, form the leaves. Mix the greens with Cadmium Yellow Medium and Prussian Blue. Some of the leaves should have more yellow at the edges. Use more light blue along the edges of others. This is where I took a bit of artistic license with the piece, since the photo was so dark. You can do the same. Have fun and experiment!

Swan

You do not often find a perfect example of a swan. This swan at our local zoo was actually posing for me. I laughed because its perfect shape reminded me of a soap dish! The photo turned out to be an awesome reference photo for artwork, with the gorgeous blue reflection of the water on the white feathers. The dark colors of the background make the swan's colors stand out even more.

MATERIALS

paints
Burnt Umber, Cadmium Red Medium, Cadmium Yellow Medium, Ivory Black, Prussian Blue, Titanium White

brushes
no. 4 filbert, no. 3/0 round, no. 2 round

Reference Photo
Use the grid method to draw the swan on your canvas paper.

Line Drawing
When you are satisfied with your drawing, erase the grid lines.

1 Begin With the Outlines

Use the no. 2 round and Ivory Black to fill in the eye and the black area around the beak. Outline some of the swan as shown. Be sure to add the line that separates the swan from the water. Mix Titanium White with a very small amount of Prussian Blue to create a light blue. Apply this to the feather area with the no. 2 round. Add some of this color to the reflection in the water below the swan.

2 The Awkward Stage

Block in the colors of the composition with diluted paint. Mix a light brown by adding a dab of Burnt Umber to Titanium White. With the no. 2 round, apply this color to the neck area of the swan as well as to some of the shadow areas of the wings.

Burnt Umber is the primary background color. Mix Burnt Umber with Ivory Black for the darker areas and with Titanium White for the lighter areas. Use a no. 4 filbert and horizontal brushstrokes. Add the same colors to the water area below the swan. Notice how the patterns in the water form a mirror image of the shape of the swan. The dark edge of black we applied in step 1 separates the swan from its reflection.

Use the no. 2 round to fill the beak with diluted Cadmium Red Medium. With diluted Cadmium Yellow Medium, fill in the small highlight area behind the neck of the swan.

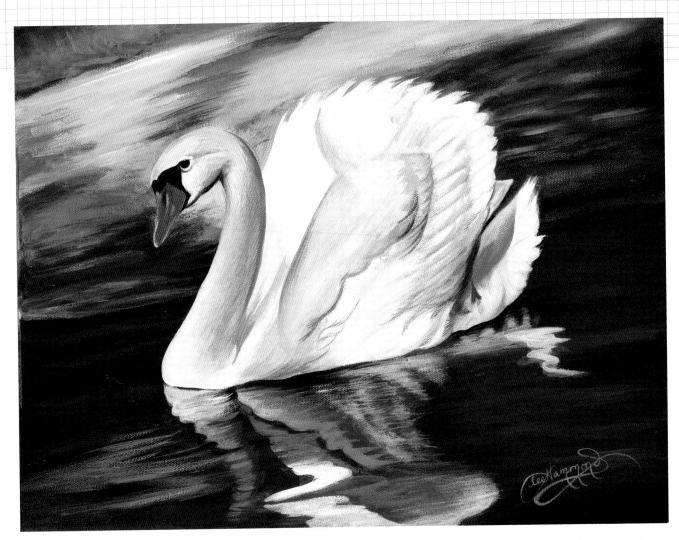

3 Finish

Apply thicker layers of color to finish. Your brush-strokes will form the textures. Look closely and you can see defined brushstrokes, especially in the background and the water reflection.

Base in the swan with Titanium White. You do not want the white of the canvas to show through. Next, layer the light brown and blue colors we used in steps 1 and 2. Use the no. 4 filbert, allowing your brushstrokes to create the form, texture and feathers of the swan.

For the shadow on the tail, mix a tiny amount of Ivory Black into the light blue color from step 1. On the back, draw in the feathers with the no. 2 round and the light brown. Edge the feathers with some of the blue.

Create the texture of the neck, where the feathers are not as distinct, with the dry-brush technique, alternating light brown and light blue over the white. Use the brown color to make the back of the neck quite dark.

Fill in the beak with pure Cadmium Red Medium, using the no. 2 round. Add a tiny bit of Ivory Black to the red, and apply the darker tone to the beak to make it look more realistic. Use a no. 3/0 round to add the reflected light along the edge of the beak with Titanium White.

Finish the background and the water with the no. 4 filbert, using the same colors we made in steps 1 and 2. Use horizontal strokes to create the textures of the background. Layer your colors from dark to light, using white last to create the look of light reflecting off the rocks.

Water reflections are fun to paint. Fill in the water with a thick layer of Burnt Umber. Add a small amount of Ivory Black to the Burnt Umber, then apply it to the brown area for the dark streaks. With the light blue and white, create the reflections of the swan, keeping the mirror image in mind. The shapes of the swan reflect straight down, but the movement of the water makes the shapes appear squiggly.

demonstration
Great Horned Owl

This photograph of an owl is another example of a stunning facial shot. I was fortunate enough to get up close and personal with many birds of prey at the Carolina Raptor Center in North Carolina. The center cares for birds that were injured in the wild. While visiting, I was able to take many gorgeous close-up photos. This great horned owl has incredible eyes. While studying the eyes, I realized that they have a striking resemblance to the eyes of a cat.

MATERIALS

paints
Burnt Umber, Cadmium Red Medium, Cadmium Yellow Medium, Ivory Black, Prussian Blue, Titanium White

brushes
no. 4 filbert, no. 4 flat, no. 2 round

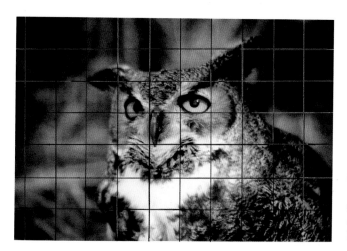

Reference Photo
Use the grid method to capture the owl on your canvas paper.

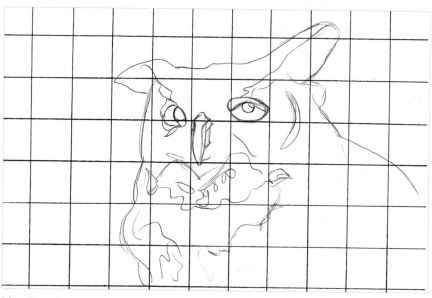

Line Drawing
When your line drawing looks like mine, erase the grid lines. Be careful. Don't remove any of the details. This is the same drawing we worked on in the exercise on page 44.

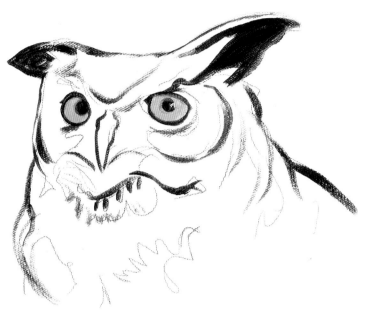

1 Begin With the Outlines

With Ivory Black and the no. 2 round, outline the eyes and fill in the pupils. Leave a small dot of white in the right eye for the catchlight. Fill in the inside of the ears and outline the basic shapes of the owl. Use the no. 2 round to fill in the irises with Cadmium Yellow Medium.

2 The Awkward Stage

Use the dry-brush technique to begin blocking in the colors. Start with the owl. With the no. 4 flat, scrub in Burnt Umber along the back, chest, and the left side of the body. Apply some Burnt Umber under the chin and to the top of the head. Scrub Ivory Black over these areas for more texture.

Mix a small amount of Cadmium Red Medium into some Burnt Umber, and add a touch of Titanium White. Apply this around the eyes, allowing an area of white to remain, and also some around the beak. Next, drybrush the same color into the front area of the owl, allowing it to overlap into the brown. Dilute some of this reddish color, then apply a shadow to the yellow of the eye with a no. 2 round. Create a blue-gray with Ivory Black, Titanium White and a touch of Prussian Blue. Apply it to the beak with the no. 2 round.

Using the no. 4 flat, scrub a blue-green mixture of Prussian Blue and Cadmium Yellow Medium into the background with a circular motion. Make an olive green with Ivory Black and Cadmium Yellow Medium, and scrub it in above the head and along the side. Scrub some of the reddish color used for the owl's face into the background along the left side, above the head and along the back.

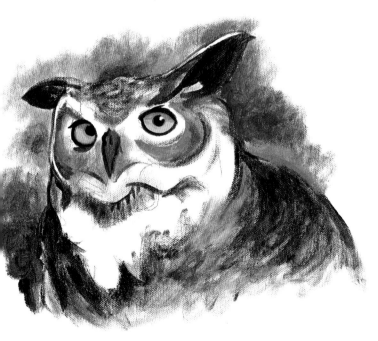

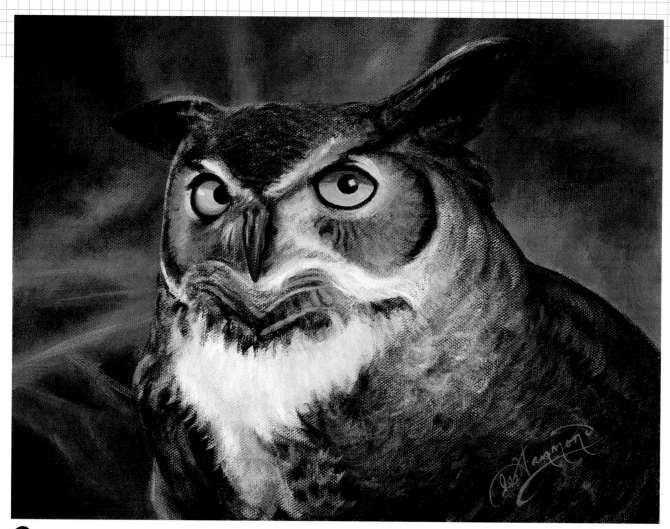

3 Finish

Apply thicker layers of paint to finish the piece. Use the no. 2 round to apply Titanium White around and above the eyes, around the beak and to the chest area. Add small dots of Titanium White to the eyes for the catchlights. In the left eye, that catchlight is in the yellow area of the iris. In the right eye, it is in the black of the pupil.

Study the painting to see how I used brushstrokes to create the feathers. They are made with curved, semicircular strokes and are layered somewhat like the shingles of a roof. Start with the deep brown and black colors, then layer the lighter colors on top. Create the lighter brown by mixing Cadmium Yellow Medium with Burnt Umber and some of the reddish color from step 2. Add these colors, using the semicircular strokes to build up the texture of the feathers. Use the same colors to texture the top of the head, but use straight brushstrokes.

Use the lighter reddish colors from step 2 in the area around the eyes. Use straight strokes that radiate outward from the edge of the eye like spokes in a wagon wheel. In the neck, this color alternates with black, making a very distinctive pattern.

Mix a very light blue with Titanium White and a touch of Prussian Blue, then use a no. 4 flat and the dry-brush technique to apply this color on top of the white area of the chest, the dark areas of the feathers and the top of the head. This produces the effect of reflected light. Switch to the no. 2 round and paint a small edge of reflected light on the edges of the ears. Apply some streaks of this color to the beak to make it look shiny. Add small dots of Titanium White to enhance the look of the shine.

Complete the background by swirling the colors from step 2 into one another. Overlap them to achieve the out-of-focus effect.

demonstration
Rose-Breasted Cockatoo

Most birds are known for their earthy colors and their ability to blend into nature. However, many birds are very brightly colored. In fact, exotic birds host some of the most vibrant colors seen in wildlife. This beautiful rose-breasted cockatoo was a wonderful subject to paint. Unlike the previous examples, where the natural green surroundings complemented the subjects' colors, the background of this painting incorporates the same coloration as the bird. I took the liberty of deepening the color to achieve more contrast. Since red and pink are my favorite colors, this painting was pure joy to work on.

MATERIALS

paints
Alizarin Crimson, Burnt Umber, Cadmium Red Medium, Cadmium Yellow Medium, Ivory Black, Prussian Blue Titanium White

brushes
no. 4 filbert, no. 3/0 round, no. 2 round

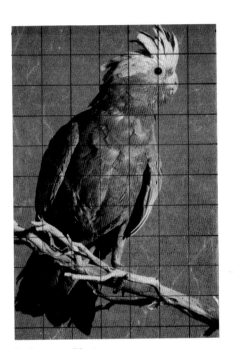

Reference Photo
Use the grid method to draw this cockatoo.

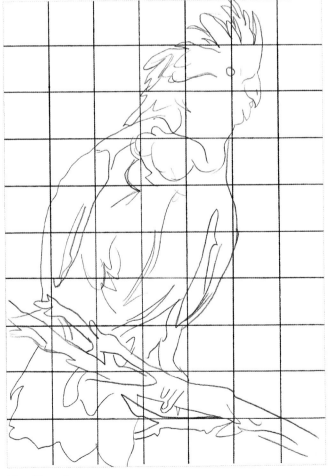

Line Drawing
When you are satisfied with your line drawing, erase the grid lines.

1 Begin With the Outlines

With Ivory Black and the no. 2 round, fill in the eye of the bird, leaving a small dot of white for the catchlight. Outline the edges of the bird and fill in the shadow areas of the wings and the tail as shown. Use some black outlines to edge the shapes of some of the feathers.

2 The Awkward Stage

Use diluted paint to block in the colors of the composition. Mix a medium gray with Titanium White and a touch of Ivory Black, then apply it with the no. 2 round to the area around the eye, the wings and the center of the tail.

Make a pink with Titanium White and a dab of Alizarin Crimson. Apply this color to the face, chest and breast area of the bird with the no. 2 round. Add some of the pink to the feathers on top of the head as well. Notice the way the black lines have created the illusion of feathers on the head and neck area.

Use a no. 4 filbert to fill in the background with Alizarin Crimson. Fill in the beak with Cadmium Yellow Medium. Base in the branch that the bird is sitting on with Cadmium Yellow Medium, too. Make a warm brown with Burnt Umber and Cadmium Red Medium. Use a no. 2 round to apply this color over the Cadmium Yellow Medium.

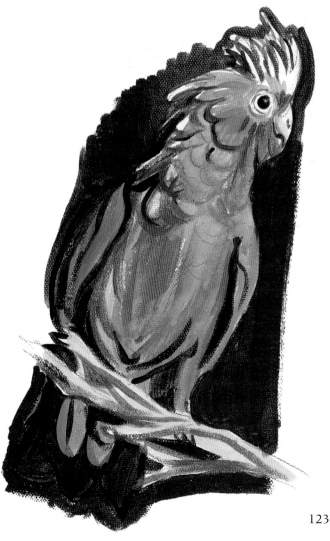

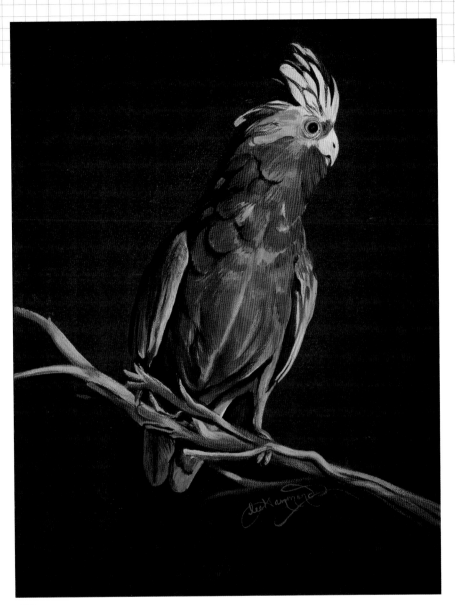

3 Finish

Apply thicker layers of paint to finish. The feathers are very important, so study them closely.

Mix a thick version of the pink used in step 2 and add a little more Alizarin Crimson and a touch of Ivory Black to deepen it. With this color, use the brushstrokes of the no. 4 filbert to form the feathers on the body. To create highlights, drybrush some of the medium gray color from step 2 on top of the deep pink. Add a tiny line of the gray along the edge of the feathers. This edge will make the feathers look raised above the black underneath.

Add a bit of Prussian Blue to the gray. Switch to a no. 2 round and apply this color to the wings and tail, using brushstrokes to simulate the feathers, as well as to the feet and legs. Add more Titanium White to the mix and create the light edges on the wings.

Use a no. 2 round and the light gray to fill in the feathers on top of the head. With a no. 3/0 round, use the same color for the small details around the eye and the highlight on top of the beak. For a more realistic effect, add a tiny dot of pink to the eye, next to the catchlight.

Use the no. 2 round to finish the branches with thick layers of the same colors used in step 2. Paint the warm brown on the under areas of the branches for the shadows. Apply Cadmium Yellow Medium mixed with a touch of Titanium White to the tops of the branches.

Alizarin Crimson is a transparent color by nature. To make it cover the canvas more completely, add a touch of Titanium White. Use the no. 4 filbert to apply it around the cockatoo. Add a tiny bit of Ivory Black to the mixture, and make the background darker in the corners. This gives the painting a natural framework and helps lead the eye toward the center.

Conclusion

Nobody said it would be easy. I wish it were as simple as 1, 2, 3, and you're done! However, these projects prove that it takes time and patience, using many layers of color, to make a painting look realistic. The final outcome is more than worth the effort. With enough practice, acrylics can become a favorite medium. You will find, in time, that there is very little you cannot do with acrylic paint. The ease in which corrections are made make it one of the most versatile and forgiving mediums available.

Don't give up. Give this wonderful medium a chance to grow with you. I promise you will not be disappointed.

Have fun! I'll see you again soon!

Index

Look for these other great titles from
North Light Books!

Fine artists and decorative painters turn to Claudia Nice time after time for her easy-to-follow, conversational instruction. And now, in *Painting Your Favorite Animals in Pen, Ink and Watercolor*, she provides 14 complete step-by-step projects that teach how to refine simple shape diagrams into drawings, add color with watercolor and finish with pen and ink details. Each final work portrays realistic animal movements, such as a stretching kitten, a dog chasing its toy and a young foal standing on gangly legs.

ISBN-13: 978-1-58180-776-9
ISBN-10: 1-58180-776-7
Hardcover, 144 pages, #33447

These books and other fine North Light titles are available at your local fine art retailer or bookstore or from online suppliers.

Bestselling author Lee Hammond is known for providing artists with friendly and easy-to-follow instruction. Perfect for beginners, this guide shows how to get started with comprehensive lessons on basic techniques using photos as a reference. Focusing mostly on painting portraits from the neck up, each project builds on the previous so you'll progressively develop your skills. Ultimately, you will master the art of painting a wide assortment of people—of all ages and ethnicities—from a variety of angles.

ISBN-13: 978-1-58180-798-1
ISBN-10: 1-58180-798-8
Paperback, 128 pages, #33476

Fine artists and decorative artists share their tips and techniques to painting the world's favorite animals: cats and dogs. This irreplaceable text includes major breeds and mixed-breed looks in a variety of poses and detail studies of fur, eyes, paws, tails and noses. *Painter's Quick Reference: Cats & Dogs* includes 40 demonstrations in watercolor, acrylic and oil and a variety of painting styles and techniques.

ISBN-13: 978-1-58180-860-5
ISBN-10: 1-58180-860-7
Paperback, 128 pages, #Z0125

Acrylic Revolution will show you everything you need to know to be successful in your acrylic painting projects. With over 101 of the most popular, interesting and indispensable tricks for working with acrylic—each with its own step-by-step demonstration—there is literally page after page of acrylic instruction and inspiration for everyone from artists, to crafters, to weekend enthusiasts, to students of all levels. A gallery of finished art at the back of the book will show you how to combine different tricks to use in your artwork, offering you real-life applications for acrylic techniques.

ISBN-13: 978-1-58180-804-9
ISBN-10: 1-58180-804-6
Paperback, 128 pages, #33483